IMAGES
of America

BERLIN

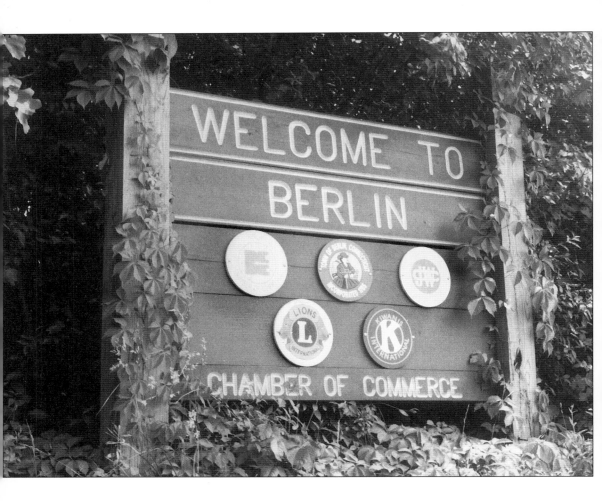

IMAGES
of America

BERLIN

Kathleen L. Murray

ARCADIA

First printed in 2001.

Published by Arcadia Publishing,
an imprint of Tempus Publishing, Inc.
2A Cumberland Street
Charleston, SC 29401

Printed in Great Britain.

Library of Congress Catalog Card Number: 2001091083

For all general information contact Arcadia Publishing at:
Telephone 843-853-2070
Fax 843-853-0044
E-Mail sales@arcadiapublishing.com

For customer service and orders:
Toll-Free 1-888-313-2665

Visit us on the internet at http://www.arcadiapublishing.com

*Dedicated to the people of the town of Berlin
whose generous contributions of photographs and memories
made the book possible.*

CONTENTS

ACKNOWLEDGMENTS

To Sara Munson and Cathy Nelson, director and assistant director-children's director, respectively, at Berlin-Peck Memorial Library, and to Arlene Palmer, city historian, New Britain, my thanks for your support and encouragement of this venture from the very beginning. Without the resources of Berlin-Peck Memorial and Berlin Free Libraries, whose directors and boards of directors allowed me to turn their local history rooms into research areas and their photographs into materials that could be borrowed to be shared in a book, there would not have been an *Images of America: Berlin*. My thanks also go to Ellie and Ginny for lending me their listening ears (by the hour); to the individual people of the town, too numerous to mention by name, who loaned me their treasured photographs and shared their memories and, in some cases, donated their materials to the David and Ann Borthwick Local History Room; and to the churches, the Berlin Chamber of Commerce, the *Herald*, the Berlin Lions Club, and the four volunteer fire departments. Finally, a very special thank-you goes to Elizabeth Wallace for proofreading the manuscript. Each of you made a difference.

INTRODUCTION

Before the advent of books, history was taught to succeeding generations by the use of storytellers. Factual stories might be distorted by the memory of the narrator and changed yet again by the interpretation of the listener when they later retold the story. So it is with this volume of *Images of America: Berlin*. Based on facts and memories of the old storytellers whose printed materials were available to me, and photographs from private collections not seen before by the general public, with the storytellers' memories of those same photographs, *Images of America: Berlin* is a collection of pictorial historical data and the memories relating to them as allowed by the publisher's space constraints and the materials available. It contains parts of the heritage of the town: the religion, education, people, places, industry, and Berlin Fair. It is not meant to be an all-inclusive history, but a volume of historical remembrances for everyone to enjoy.

The first settler of the town was Sgt. Richard Beckley, a planter, who purchased 300 acres of land along the Mattabesset River from a Mattabesset chief named Tarramuggus. For 15 years Beckley lived peaceably with the Native Americans as the only white man living in the area. His 300 acres, called Beckley Quarter, were from what are today parts of Wethersfield, Rocky Hill, Cromwell, and Middletown. Beckley's home, the oldest home in Berlin, still exists as a farm, raising and selling vegetable and flower plants to neighbors in surrounding towns.

In 1686, Capt. Richard Seymour led a group of 14 families living in the village of Farmington to a remote southeastern section of that town to establish a new area. It was known as the Great Swamp Settlement of Farmington. From a religious background, those families had to travel eight to ten miles at least once every week, summer and winter, to attend church.

By 1705, because of the difficulty in traveling, the settlers had petitioned the General Assembly to be set off as a separate parish. As a result the Great Swamp Church was gathered in 1712, with the Rev. William Burnham called to lead the group. A teacher was also required for every 50 households, and the beginnings of school districts were formed. In 1722, the General Assembly renamed the Great Swamp Settlement Kensington.

By 1732, a new and larger church was needed. Although its site was controversial, the new church was built just down the road from its present location. Within a few years, unrest in the church caused a division of the people, and the Kensington church was divided into two, called the East and West Parishes. Two new churches were planned and, in 1774, the Second Church of Farmington (now Kensington Congregational Church) was built in the west parish, followed in 1775 by the Christ Church of Worthington in the east parish (now Berlin Congregational

Church), utilizing some of the timbers from the old church. In 1754, another ecclesiastical society was established in Farmington, the New Britain Society, and the First Church of Christ Congregational was built.

In 1781, the people petitioned the General Assembly to create a new town. That petition was denied but, in 1785, the town of Berlin was incorporated, containing land that was part of what is today Kensington, Berlin, East Berlin, and New Britain.

Although the early communities were essentially agrarian, industries began to appear in the 18th century to meet the needs of the people. Blacksmith shops, gristmills, and sawmills were set up along the streams and rivers. In 1740, the Pattison brothers emigrated from Ireland and opened the first tinsmith shop. As needs of the local farmers were met, the brothers expanded their selling area, first by carrying goods on a horse with baskets, and then by use of horse and wagon, creating the term "Yankee peddler."

District schools provided secondary education for youngsters. In 1801, the Berlin Academy was opened, followed a few years later by the Worthington Academy. Until the 1930s, there was no provision for higher education in Berlin.

Industry began growing throughout the town and, in 1850, many of the larger industries were in the New Britain area. Berlin and Kensington had applied to be separate towns, but the General Assembly separated New Britain from them instead. Industries in the Berlin area were mostly located in the Worthington section of town and consisted of everything from carriage making, general merchandising, and silk worm raising (for thread) to hotels and inns. Many homes had shops in their backyards and utilized apprentices to work in them.

Berlin men fought in the Revolutionary and Civil Wars, and townspeople have continued to the present day to be available to fight whenever duty called to protect our homes and country.

Many distinguished people lived in Berlin. Noted among them were Emma Hart Willard and her sister, Almira Hart Phelps, both educators who spoke out for the education of women; Nelson Augustus Moore, an artist; Robert Bolling Brandegee, an artist; James Gates Percival, a physician, poet, and author; and Rev. Royal Robbins, an author and minister.

By 1858, many Catholic immigrants had moved into the area, and churches other than Congregational began to appear. Today, the three sections of town support a variety of churches of all denominations and a spirit of ecumenicalism exists throughout town.

The Kensington, Berlin, and East Berlin areas have grown and continue to develop, but at a leisurely rate. Small industries thrive; larger industries exist and help support a growing tax base. Many small schools have consolidated into three elementary schools, one in each section of town, with a middle school and high school located centrally in the Berlin section. Most of the large farms are gone now, subject to redevelopment, but small farms still survive. Government is under a town manager-town council system, which appears to be right for Berlin. For protection the town has an efficient and accredited police department and four volunteer fire departments. Berlin is a good place to live and an interesting place to visit.

One

FAITH IN GOD,
LOVE OF LEARNING

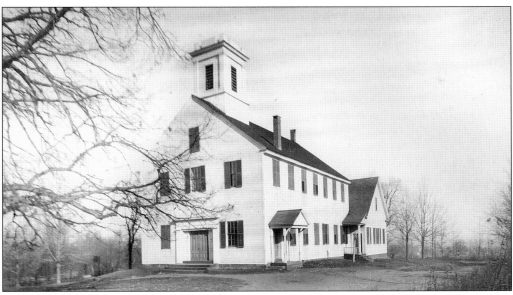

Early settlers believed in their Bibles, and attending church was very important to them. This is Kensington Congregational Church *c.* 1900. Organized on December 12, 1712, the first church, known as Christian Lane Church, was built in the Great Swamp Settlement. It opened with a membership of 10: seven men and three women. By 1732, a larger church was needed, and another meetinghouse was erected nearby. After much unrest due to the new location, the church split, dividing into east and west parishes. This meetinghouse, erected in 1774, used some of the timbers from the 1732 church. The church has been in continuous use since that date. It is said that Native Americans used to have council meetings and smoke their pipes around the tree. (Berlin-Peck Memorial Library.)

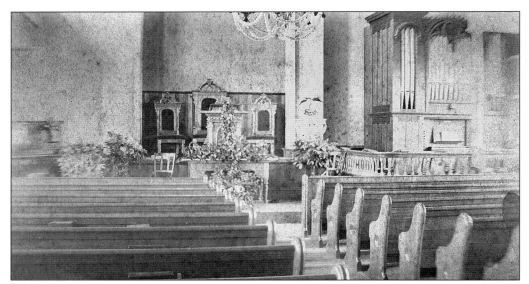

The interior of the meetinghouse is decorated for a special occasion in 1884. Even the chandelier has a garland hanging from it. The original pews of the church, which were square and faced west, were replaced in 1837 by pews like these but having doors. The first organ was installed in 1865. (Kensington Congregational Church.)

The building of an outdoor worship center was undertaken by the Pilgrim Fellowship, fashioned after Cathedral of the Pines in New Hampshire. On November 23, 1963, after many hours of clearing trees and filling and leveling gravel and creating seats from donated telephone poles and metal braces, Chapel in the Woods was dedicated. Stones used in building the altar were received from youth fellowship groups located in other Congregational churches in Connecticut.

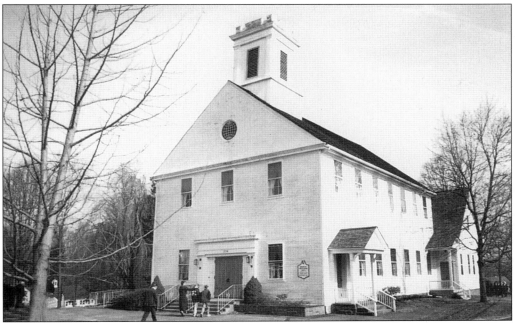

Today, Kensington Congregational Church still stands. The old oak tree came down in a storm many years ago and has been replaced by a new tree. A parlor, some offices, a parish house, and Reeves Educational Center have been added and are used for a variety of purposes, including Sunday school and a preschool for three- and four-year-olds. (Kensington Congregational Church.)

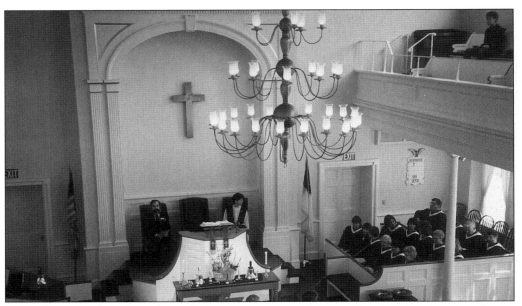

Recently renovated, the upstairs balcony was opened to provide additional seating for an increasing number of worshipers. The chandelier and cross are made of pewter, and the interior includes off-white walls, a pale blue ceiling, and gold trim.

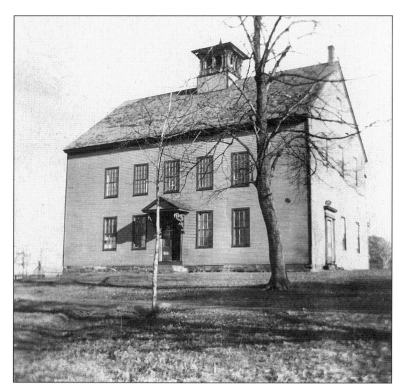

The meetinghouse of Eastern Parish, Church of Christ in Worthington, was dedicated in 1775. The cupola on the building has now been removed for safety purposes. Partially destroyed in a fire, the building was later used as a town hall, a school, and board of education offices. Timbers from the 1732 church were also used in the construction of the meetinghouse. (E.S. Benson.)

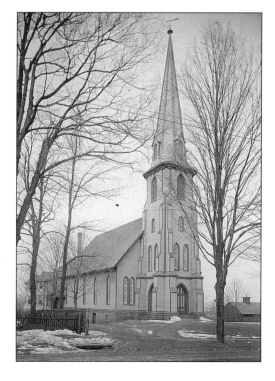

Located on Worthington Ridge, Third Church of Berlin replaced the meetinghouse in 1850. Constructed in Greek revival style, it is still used today. Known as Berlin Congregational Church, its lovely steeple can be seen for miles above the treetops. In a spirit of unity, which still persists, this church hosted the first ecumenical service between Catholics and Protestants at Thanksgiving in 1963. It also had the first organ played in a Congregational meetinghouse, given by Jedidiah Norton. (Berlin Free Library.)

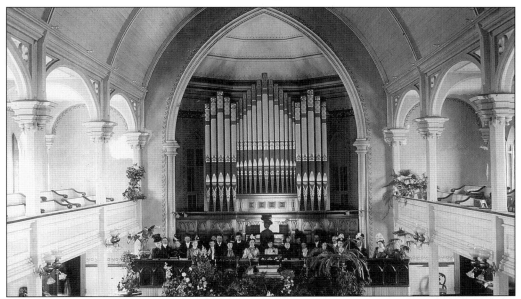

This is the interior of Berlin Congregational Church as it appeared in 1890. The organ was a two-manual-tracker-action, eight-rank manually operated pipe organ, noted for its purity of tone. The interior of the church has been remodeled several times, with the circular area in front of the rail removed and pews placed in a straight line across the front of the church. At the time of this photograph, the choir faced the congregation when it sang. (Berlin Free Library.)

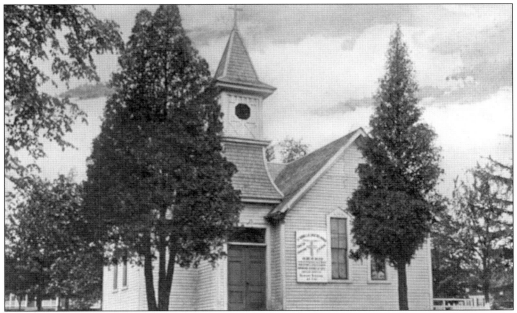

In 1888, Kensington Congregational Church built this chapel at Upsons Corners for use as a meeting place and chapel. After St. Paul's church burned in 1913, that congregation used the chapel until a new church was built. Sold in 1919, the chapel now houses a beauty salon. (Kensington Congregational Church.)

These old beams are from the 1732 church. They were found during the recent remodeling of Kensington Congregational Church. Pegs were used to hold the beams together. Lumber for both the 1712 and 1732 meetinghouses probably came from the Bronson Mill on Mill River. A gristmill was also located at that site, and these mills may have been the oldest ones in Kensington.

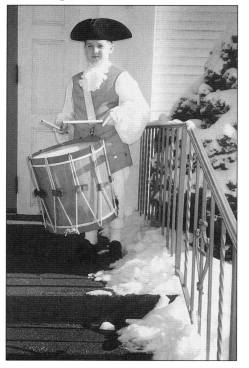

Before the installation of church bells in the mid-1800s, a drummer was used to call parishioners to services. During a recent reenactment of a Colonial Sunday service, conducted by the Women's Service League, Kensington Congregational Church, Roger Thompson performed the duty, using traditional costume and drum.

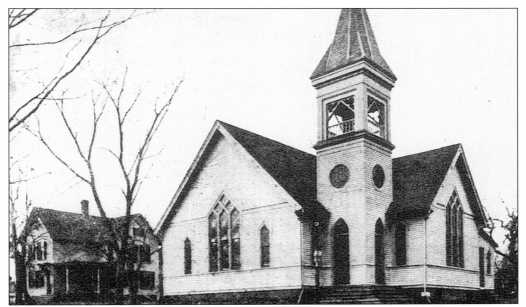

Kensington Methodist-Episcopal Church was organized in 1858 from Berlin Methodist-Episcopal Church. Worship was held in Kensington Town Hall for seven years until the church was built on a lot next door. The present church was built in 1893 on land donated by Edward Alling. Many additions have been built since that time. In 1966, the parsonage next door was determined to be unsound. It was subsequently torn down and replaced by a parking lot. (Kensington United Methodist Church.)

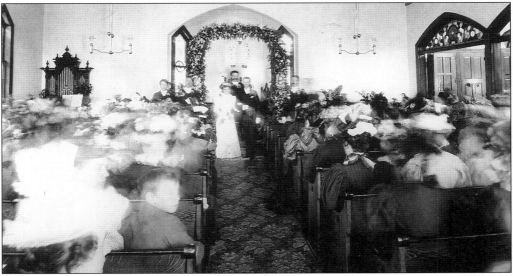

The wedding of George Boyer to Charlotte Cushman took place on June 16, 1897. The pews are from the original Kensington Methodist-Episcopal Church, brought by placing them crossways on a wagon to make only one load. The story is told that they were too wide to cross the bridge at Paper Goods and had to be unloaded, reloaded lengthwise (two trips), unloaded, and reloaded again crossways to finish the trip to the new church. (Kensington United Methodist Church.)

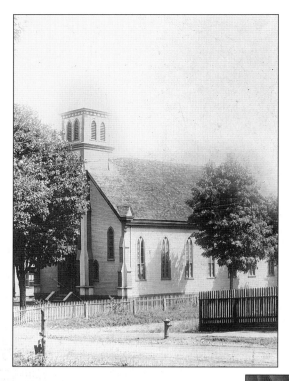

In 1855, the first Roman Catholic worshiper came to Kensington. Within a year, other families came, forming a core group. Rev. Luke Daly, from St. Mary's Parish, New Britain, came to organize the families, and Mass was said for the first time in 1872 in Hart's Hall. By 1878, with an increase in the size of the congregation, it was apparent a church was needed. This is the first St. Paul's Roman Catholic Church. (St. Paul's Roman Catholic Church.)

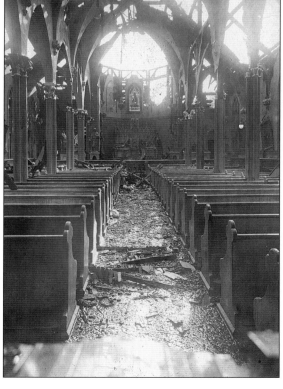

Tragically, in 1913, a fire of mysterious origin occurred during the night, causing the church to be almost a total loss, although the rectory next door was untouched. Father Brennan, the priest at the time, ran into the burning building and was able to save the Blessed Sacrament. (St. Paul's Roman Catholic Church.)

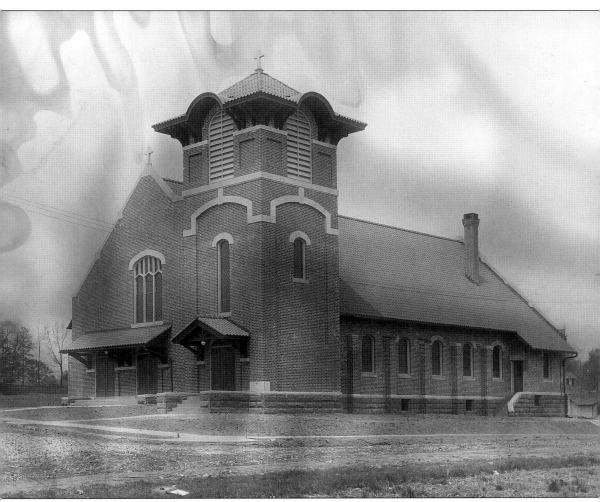

The cornerstone for the new church was laid in November 1913. Today, St. Paul's has the single largest church membership in town. It also has its own convent and parochial school. The bell from the original church rings from the current bell tower. From 1931 to 1948, St. Paul's had a fife-and-drum corps, which began with a group of untrained young men and went on to win state championships for 17 consecutive years, winning over 500 trophies. Families who could afford it during the early years rented their own pews for a charge of $3. Over the years many social organizations began in the parish. Sisters from St. Mary's Church gave religious instruction until the convent was built in 1950. By 1964, growth in church membership was responsible for the addition of another wing to the church. (St. Paul's Roman Catholic Church.)

Organized in 1864, the chapel of East Berlin Methodist Church was finally dedicated in 1876 to serve the needs of parishioners too far away to travel conveniently, especially in bad weather, to Cromwell and Middletown to worship. (Berlin Free Library.)

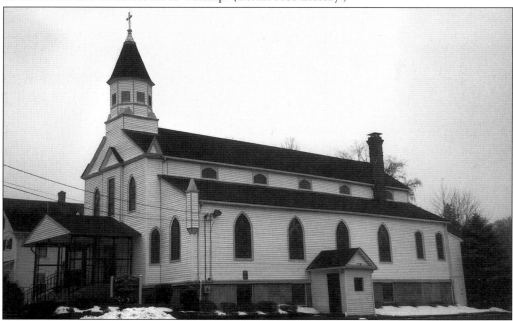

As Berlin Iron Bridge Company, East Berlin, developed and needed more laborers, the number of Catholics in East Berlin increased and so did the need for a Catholic church. Sacred Heart, dedicated in 1897, held its first baptism and funeral in May of that year and its first wedding in 1901. Sacred Heart was a mission church of St. Paul's but formed its own societies. In 1967, it was established as a full parish, with Rev. Robert Carroll appointed its first resident pastor.

During a special Sunday service, an octave of hand bells was dedicated to ring out music to the glory of God. In the town of Berlin, where music of all kinds has been and is a way of life, many of the churches have children's and-or adult hand-bell and chime choirs.

When informed that Fort Sumter had been fired upon, the Rev. Elias Hillard put aside his prepared sermon and preached such a patriotic oration that the women of Kensington Congregational Church met to handcraft an American flag, designed as shown, which flew from the belfry throughout the Civil War. The flag is currently being restored and will be archived and displayed.

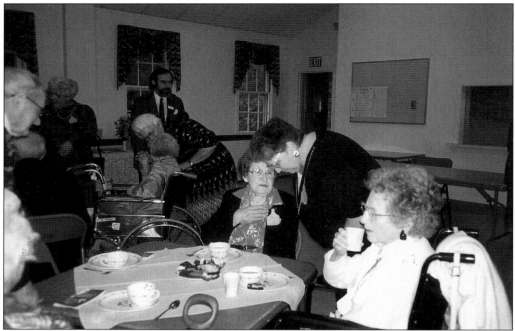

The Gathering is one of many special services offered by churches for members, in this case, senior citizens. Transportation is provided for shut-ins, nursing home residents, and others who may not normally be able to attend services in the sanctuary on a regular basis. The service is followed by a tea and a time to visit with one another. (Kensington Congregational Church.)

Children at Kensington Methodist Church pose for a Sunday school photograph in the early 1900s. Note the beautiful stained glass windows in the church. (Ella Williams.)

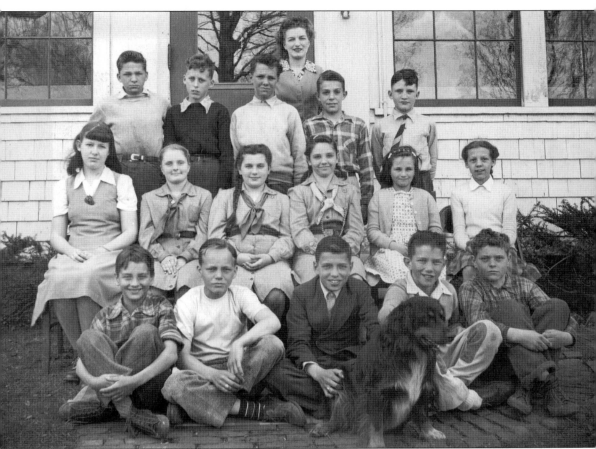

These young people are members of the fifth- and sixth-grade Classes of 1946 at Percival School, a two-room schoolhouse serving four grades. There are eight sixth-graders and seven fifth-graders in the photograph. The Girl Scout troop met at the church across the street after school. Virginia Nolan (rear) taught these two grades. Pictured, from left to right, are the following students: (front row) William Schwab, Henry Firnhaber, Paul Dubec, Eugene Anderson, and Donald King; (middle row) Phyllis Wanet, Evelyn Podlasek, Jacqueline Barber, Kathleen Lane, Christine Delaney, and Victoria Schnitzke; (back row) Lewis Burdock, Lawrence Clark, Sidney Burdock, Frederick Beach, and John Schoell.

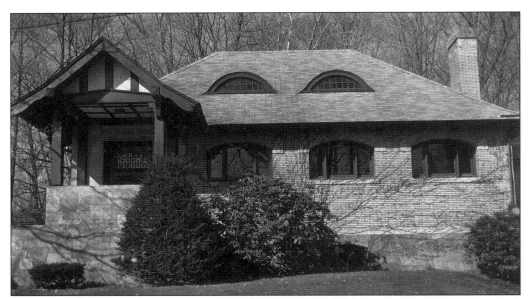

On May 1, 1901, the Kensington Library Society signed articles of incorporation "to establish and maintain, in said parish of Kensington, a free public library and reading room, and to promote such other literary, scientific and social objects as it may deem proper." The new library was built on land donated by the Hotchkiss family. (Berlin-Peck Memorial Library.)

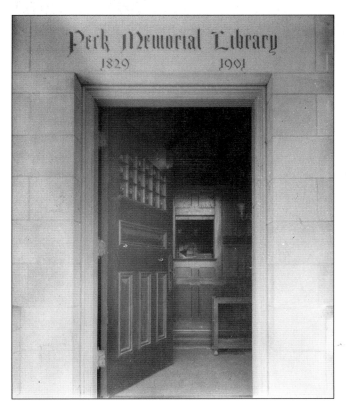

The entrance to Peck Memorial Library shows the book checkout window through the open doorway. The heavy wooden exterior door had bull's-eye glass panes over panels. (Berlin-Peck Memorial Library.)

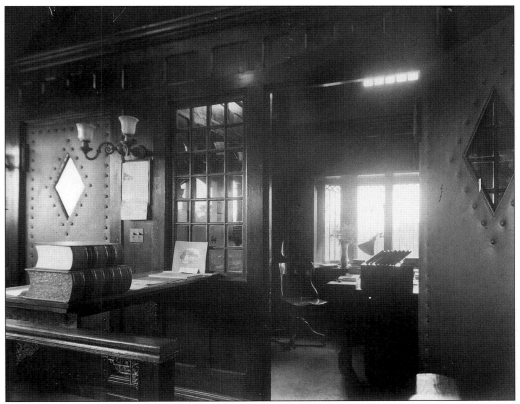

The office at Peck Memorial Library shows beautiful leather facing on the doors. The well-designed braces on the railing were prepared of wrought iron *c.* 1903. (Berlin-Peck Memorial Library.)

By 1963, growth in the town's census was showing the need for an expansion of the library. A new wing was planned, designed to enhance and blend with the present building. No longer utilized as a library, but still owned by the town, the building now houses the Berlin Historic Society Museum. (Berlin-Peck Memorial Library.)

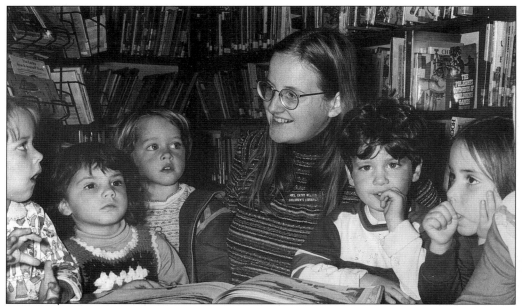

Children's librarian Cathy Nelson captivates an unidentified group of children during story hour at the old library. The new Berlin-Peck Memorial Library offers many special programs for youngsters, including story hour under the continued direction of Cathy Nelson, now the library's assistant director and children's director. (Berlin-Peck Memorial Library.)

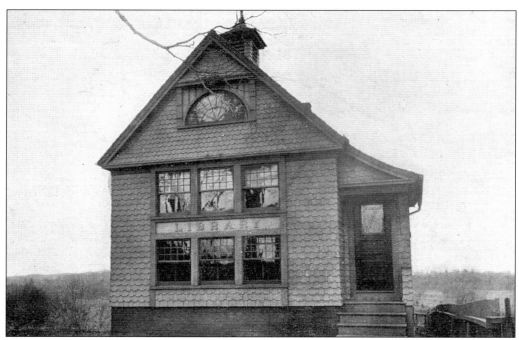

The books of the first library in the Eastern Parish were kept behind the pulpit in the meetinghouse. The library moved many times as it grew, finally moving into this building, known as the Berlin Free Library, in 1892. (Berlin Free Library.)

With the exception of Jeanette Honiss, far left, the children in the Worthington School classroom *c.* 1912 are unidentified. (E.S. Benson.)

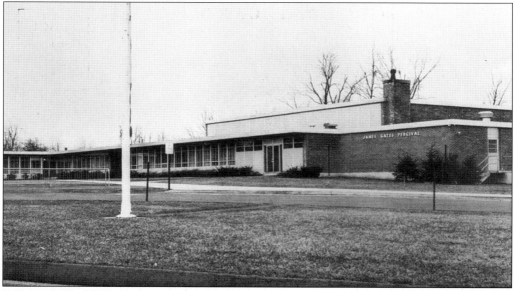

Following World Was II, new schools were constructed to take care of a rapidly increasing population and to replace some older buildings. Today, the James Gates Percival School has been converted to senior apartments and a senior center. In the senior complex, activities and classes are held daily, a small library is available, and hot meals are available daily to all seniors for a minimal price. (Berlin-Peck Memorial Library.)

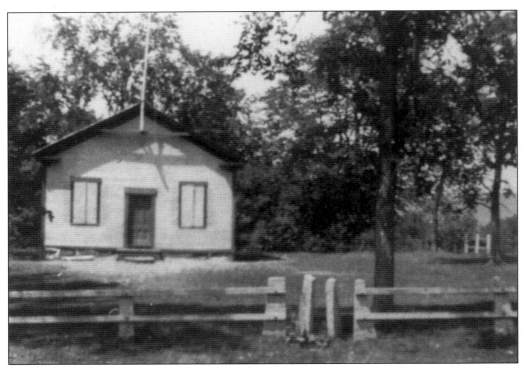

Finding it inefficient to hire teachers for and to support the operation of many one- and two-room schoolhouses, the town decided to build a single, centrally located school and to close five outlying ones. Closed were Pond School, which was located by Paper Goods Pond, before it was destroyed by fire; Christian Lane School (lower right) and West Lane School (upper left), both of which were enlarged and converted into private residences; Kensington Town Hall, which

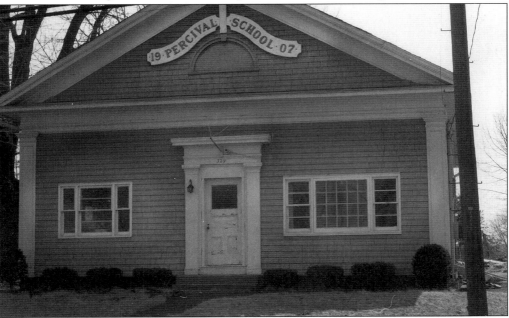

became Percival School (lower left) in 1907, closed in 1910, reopened once again as a school, and ultimately became a private residence; and Ledge School (upper right), large enough for 40 to 50 students, now the Community Art League building. Today, the three sections of town support three elementary schools, one middle school, and one high school. (Berlin-Peck Memorial Library / the Herald.)

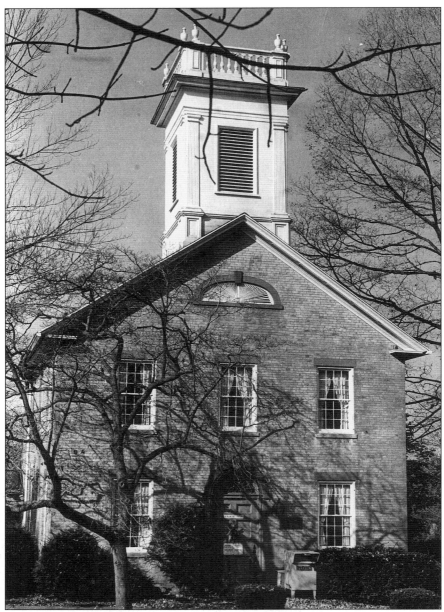

Two academies were organized in Berlin: one in 1801 and the other in 1831. The Worthington Academy, the later one, became a meeting place for social and religious occasions. Latin, Greek, French, English, chemistry, mathematics, and drawing were taught. By 1835, the academy had 200 students coming from as far away as New Jersey and Georgia. However, by 1873, interest in the academy had lessened and the school had to be closed. Berlin Congregational Church rented the building for a few years. Then, it was sold to the Brandegee family, who made a residence there. In 1951, at the death of Emily Brandegee, the building was left to the Berlin Free Library Association. Today, it houses the Berlin Free Library, with a collection of approximately 14,500 books, a children's room, an adult room, and a small museum. (Berlin-Peck Memorial Library / the Herald.)

Mooreland Hill School was founded in 1930 in a private home and was known as Shuttle Meadow School. Incorporated in 1931, the school needed a more suitable location. E. Allen Moore donated to the corporation the Blair Farm and a small parcel of land, where the college preparatory school Mooreland Hill is currently located. (Mooreland Hill School.)

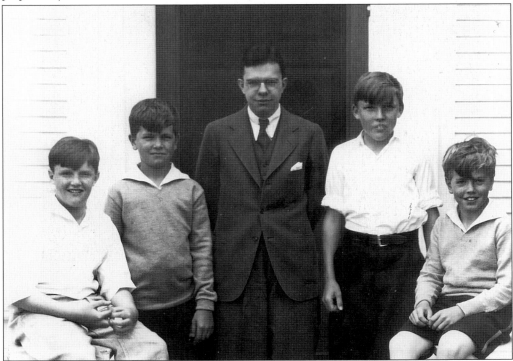

Four young men made up the first class at Shuttle Meadow School. Shown with headmaster Alexander Kern (center), they are, from left to right, Howard Eddy, Donald Hart, Robert Frisbie, and David Hart. (Mooreland Hill School.)

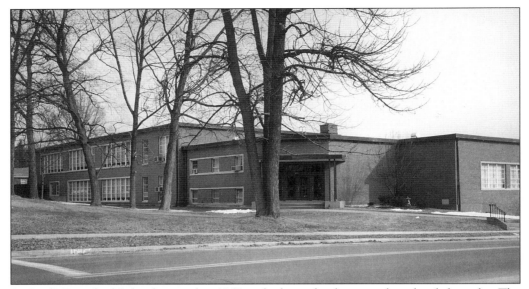

St. Paul's Parochial School opened in 1958 with classes for the seventh and eighth grades. The following year, ninth grade was added and, in 1970, sixth grade was added. Children attended St. Thomas Aquinas School in New Britain for parochial high school. St. Paul's Parochial School now teaches preschool to eighth grade.

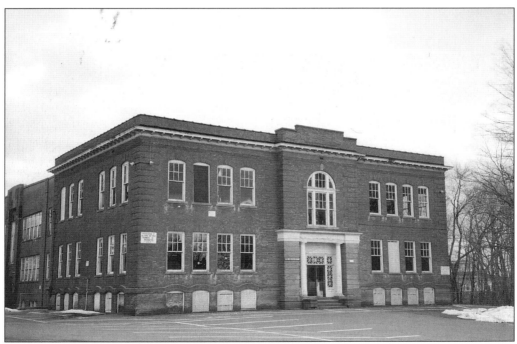

Kensington Grammar School was opened in 1910 to bring together students from many small outlying schools. The cornerstone box was removed in the year 2000. Inside it was found pages with the signatures of all the students transferred to the new school. Those pages are now stored in the David and Ann Borthwick Local History Room at Berlin-Peck Memorial Library.

Two

PEOPLE ON THE MOVE

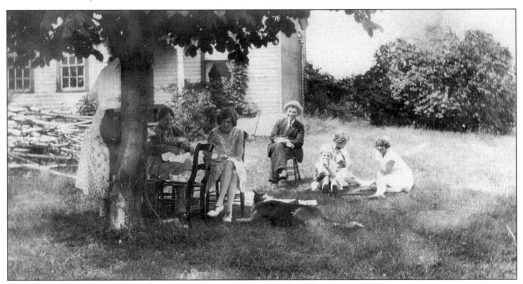

Large farms existed throughout the Kensington, Berlin, Beckley, and East Berlin areas. Today, much of the land from these farms has been sold to individuals or developers for homes. Enjoying a quiet day in 1929 at the Claudelin Farm, on Kensington Road, are, from left to right, Mathilda Claudelin, Agnes Roos, Greta Roos, Charles Claudelin, Ruth Claudelin, and Hildur Claudelin. (H. Bacon.)

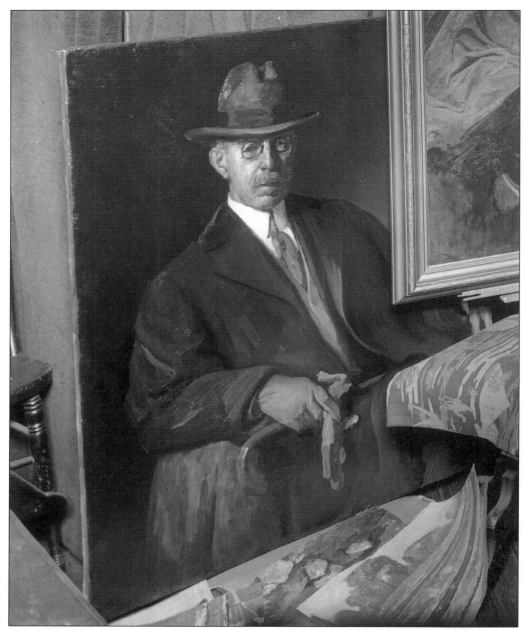

Robert Bolling Brandegee (1848–1922) was born in Berlin. Considered a professional realistic artist, he has had paintings exhibited in galleries both locally and worldwide. This unframed painting of him is by one of his students. As a teenager, Brandegee showed a love of hunting, fishing, and swimming and had a special interested in botany and ornithology. He began painting at the age of eight, after receiving a gift of watercolors from his aunt. He was a student at the Worthington Academy. As a young man, he taught painting in Hartford. In 1872, he went to France to study under M. Jaquesson. Returning from France, he taught at Miss Porter's School in Farmington and Miss Dow's School at Briarcliff-on-the-Hudson. Portraits were considered his best works. (Berlin-Peck Memorial Library.)

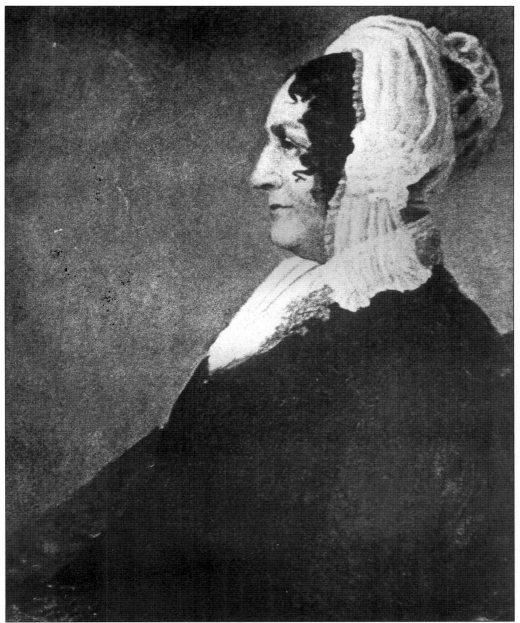

Born in Berlin in 1787, Emma Hart Willard was always interested in education. By the age of 19, she had become a teacher at the Berlin Academy, where she taught for many years. An author of both poetry and prose, she also wrote books on geography, astronomy, and history. It became her purpose in life to help women seek better education, and she took a public stand on this issue. She opened a girls' seminary in Troy, New York, where at one time she cared for 400 girls. She was elected to the Hall of Fame. This portrait of her is a copy of a painting by Robert Bolling Brandegee. (Berlin Free Library.)

Marjorie Moore became postmaster in 1907, after the death of her father. She was devoted to the town and was a supporter of Peck Memorial Library. Because she was a benefactor to Kensington, her will set up the Marjorie Moore Charitable Foundation for the benefit of town charities and governmental services, donating funds to the library, town pool, fire department, senior center, and YMCA. among other places. (South Kensington Volunteer Fire Department / Murray.)

In July 1992, the Monday Night Club celebrated the 124th birthday of Marjorie Moore, a charter member of the group. Marjorie Moore loved large hats and, at her birthday party, all the women wore big hats in her honor. Members of the Monday Night Club celebrate her birthday annually, and they still wear big hats for the occasion.

Helen Roys was a teacher at a private school in her own home on Worthington Ridge and at the South School in Berlin. (E.S. Benson.)

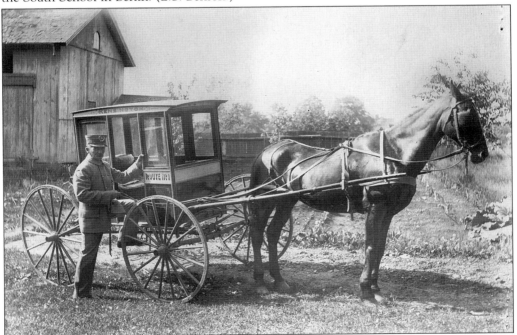

As late as 1825, mail for Berlin and neighboring towns was located in the post office in Berlin, which occupied one room in the Berlin Hotel. Charles Williams was reported to have been the first rural U.S. mailman. (Berlin-Peck Memorial Library.)

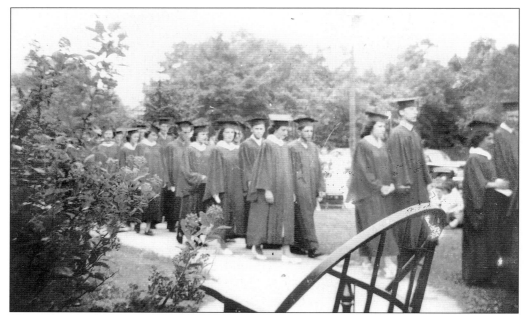

Shown here is the Class of 1949 marching up Senior Walk to the class day program at Jean E. Hooker School in Kensington.

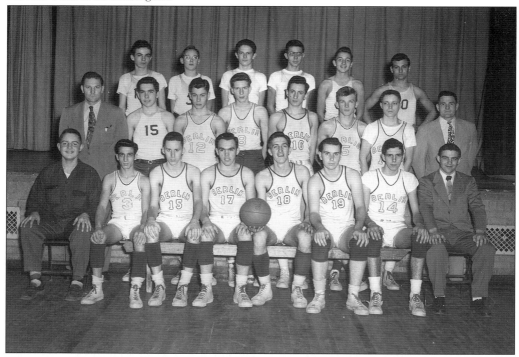

The town of Berlin has always encouraged a variety of sports. These young men are the high school basketball team of 1952, coached by Roy Fabian (middle row on the left) and William Gibney (middle row, on the right.) In addition to basketball, the football and baseball teams carried on a winning tradition, bolstered by the the high school cheerleading squad.

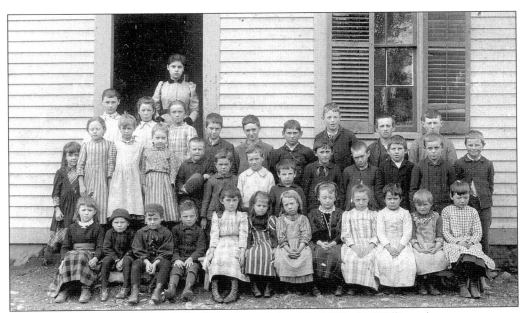

Shown in this view is a class of the West Lane School in 1892. (E. Williams.)

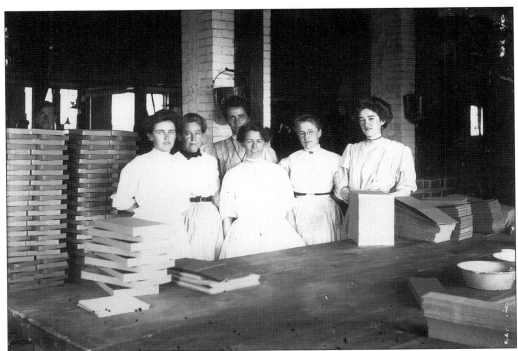

The women in this photograph are listed as the "box department employees." They probably worked at the American Paper Goods Company. (Berlin-Peck Memorial Library.)

Charles M. Jarvis, schooled as an engineer, was offered a position at the Berlin Iron Bridge Company, where he did drawings, estimates, and bookkeeping. At first working with construction of iron bridges, he recognized the need for development of iron and steel in buildings and guided the company in that direction. He became vice president of the company, which by then was called American Bridge Company, and earned recognition as a prominent businessman. (E.S. Benson.)

Rev. Luke Daly of St. Mary's Church in New Britain said the first Mass for Catholics in Hart's Hall in 1872. Daly was instrumental in the purchase of land on Main Street for St. Paul's Church, a mission church, which did not have an assigned resident pastor until 1881. (St. Paul's Roman Catholic Church.)

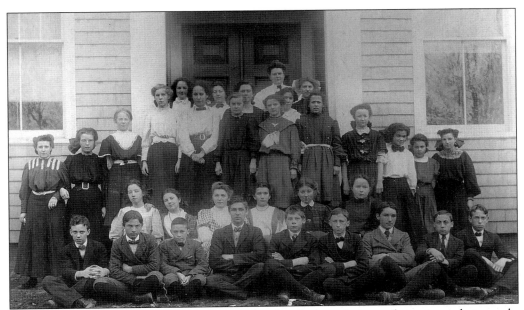

This early-1900s class at the Worthington School gathers on the steps for a group photograph. (Berlin Free Library.)

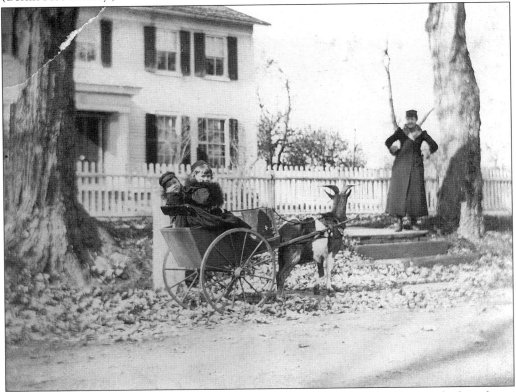

Children often used goat and pony carts as a means of transportation. The two little girls are Grace Jarvis and Juanita Fields. (E.S. Benson.)

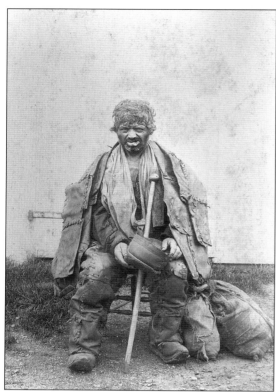

Jules Bourglay, known as the Leatherman, was a wanderer who became famous because of his rigid schedule of walking 340 miles between the Hudson and Connecticut Rivers every 34 days and returning to the same homes for food handouts. He always wore all leather clothes, which he made from scraps of leather and old boot tops, said to have weighed about 60 pounds. The Leatherman communicated using pantomime and was noted to be kind, gentle, and religious. (E.S. Benson.)

The Leatherman often slept in a cave at the foot of Short Mountain, under the rock in the center of the photograph. A short distance away, at Short Mountain Farm, "Grandma Ross" (Mary Katherine Ross) used to feed him porridge from a blue pail (he had difficulty eating due to cancer of the lip).

Rev. Royal Robbins was settled as pastor at Kensington Congregational Church in 1816. Said to be a loving and learned man, he was noted for his work with children. He taught at a school and studied law before becoming a minister. He was a well-known author, whose many religious publications and *Outlines of Ancient and Modern History*, adopted by many schools as their text, were written to help support his large family. (Kensington Congregational Church.)

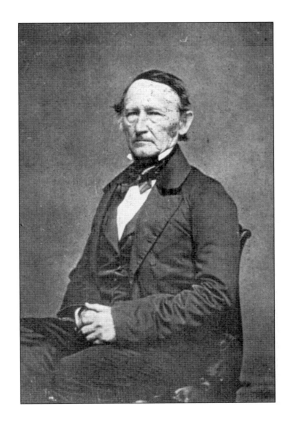

Shown here is Clara Louise Shumway, dressed for her wedding to Arthur Woodruff. Arthur and Clara Louise Woodruff made their home on Worthington Ridge. He worked for his father in the grocery and feed store. The couple celebrated their 50th wedding anniversary at an open house in their home in 1955, which was attended by many of their friends. (Berlin Free Library.)

Shown in this view is C. Fred Johnson, dressed for his wedding. In the milk business, Johnson operated under the name of Springdale Dairy and kept his own herd. He was active in town and church affairs, serving on the board of selectman, on the board of assessors, and as an incorporator of the Berlin Savings Bank. (S. Johnson.)

In this view, Blanche Louise Crane, fiancée of C. Fred Johnson, is wearing her wedding outfit. Marriages often took place at an early age. Prior to the arrival of the immigrants in the 1800s, intermarriages were not uncommon. (S. Johnson.)

Nelson Augustus Moore worked at a variety of jobs, including railroad agent, miller, and photographer. He owned the first daguerreotype studio in New Britain. He studied painting in New York and taught drawing at the Normal School in New Britain. Moore helped raise funds for the Civil War Monument at the Kensington Congregational Church. By the age of 40, he was devoting his life to painting, first as a portraitist and later as a landscape artist, painting nature as it appeared to him. (Ellen Maria Moore, New Britain Museum of American Art / photograph Blomstrann.)

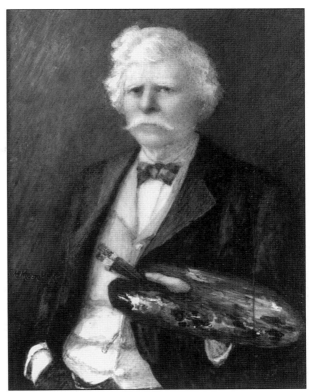

Simeon North, son of Jedediah North, was noted for his pistol factory. By 1808, he had become the first official pistol maker for the U.S. government. Visited by Pres. James Madison during the War of 1812, he was requested to increase production. As a result he opened a second factory. His pistols had interchangeable parts. At the close of the war, he made two mounted sets of gold pistols as gifts at the request of the president. (Berlin-Peck Memorial Library.)

Ready for a 1947 concert are the Berlin Choral Society and the Mannerchor of New Britain. In the center front, from left to right, are accompanists Charles Johnson and Madeline Gerrish Gay and director William V. Harris. The Berlin Choral Society was organized in 1936 to promote the advancement of choral music in the community. It offered scholarships to young people wishing to continue with music training. It presented productions such as Bizet's *Carmen*, and brought talent to the community such as Metropolitan Opera Association contralto Anna Kaskas and baritone Robert Weede. The society became inactive in 1956. (Berlin Free Library.)

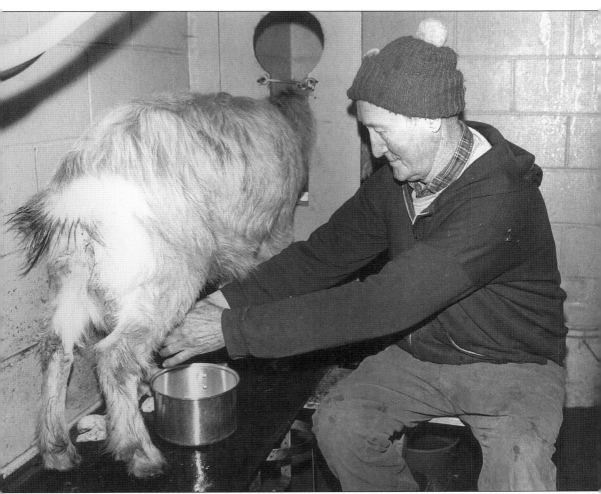

Have you ever seen the bright red van labeled "Goat Farm"? or have you been to the goat barn at the Berlin Fair? Ed Linn, the well-known Goat Man, had the courage to retire to the country, buy a lot, have a home built, and follow his dream of becoming a farmer. Now 84, Linn has been raising goats for 29 years. He was licensed by the state of Connecticut to sell raw goats' milk, which is easily digested by infants. His largest herd included 12 milkers. Four pediatricians referred their clients to him. One of the babies his goats gave milk to is now in college. Linn no longer sells the milk. He has four milkers left that he "kids" in the spring. Jill, his special pet, follows him around the yard. The goats now visit seniors in convalescent homes and schools, where children are allowed to bottle-feed them. (Anderson Studios / Linn.)

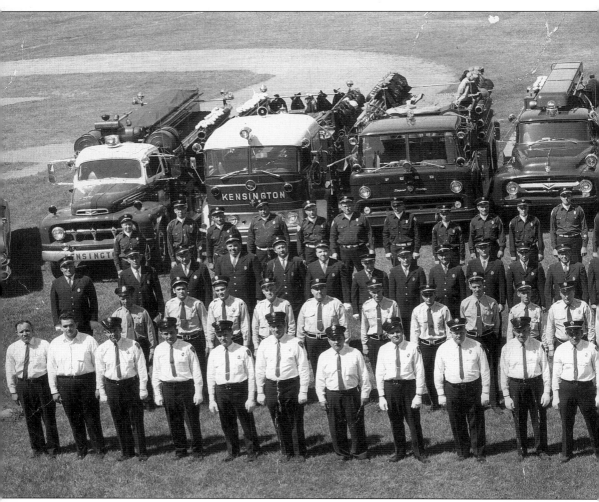

Until 1932, the New Britain Fire Department came to the rescue of the town for fire emergencies, often arriving late due to the distance to be traveled. In 1932, East Berlin created the first of four volunteer fire departments to be formed. Kensington Volunteer Fire Department organized in 1938. The department used lumber from an old home located in the Holmes Brickyard, sold to them by the town for $1, to build the fire station. The Kensington Volunteer Fire Department still maintains ownership of its building. In 1943, the decision was

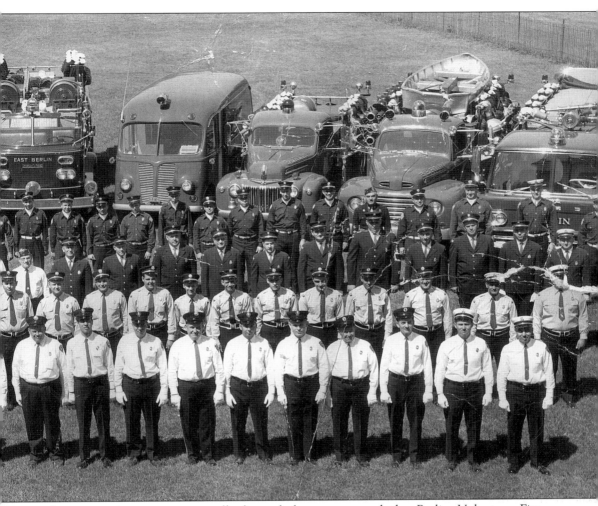

made to organize a more centrally located department, and the Berlin Volunteer Fire Department was born. The group started with 15 members and an old Ferndale Dairy Milk truck converted into a fire truck. The South Kensington Volunteer Fire Department was formed in the 1950s. Using the only building owned by the town, the department raised money by selling candy and, with grant money, converted the old school building into a firehouse and purchased the department's first truck. (Kensington Volunteer Fire Department.)

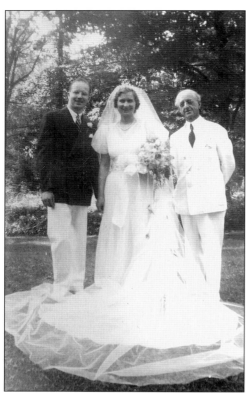

The wedding of Roger Morse to Hildur Claudelin took place on June 21, 1941. The Rev. Lewis Johnston officiated. The reception was held in the church parlor. The couple honeymooned in Niagara Falls. (H. Bacon.)

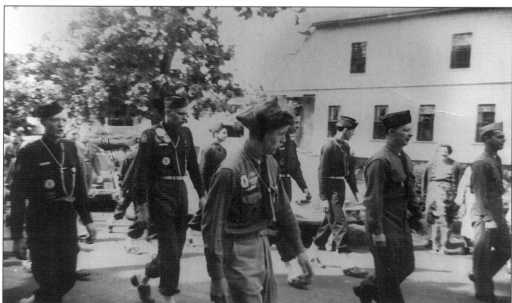

Memorial Day Parades are held annually on a rotating basis in the three towns, with services usually held at the war memorial monuments. Young people are among those invited to march, such as this group of Boy Scouts from the 1950s, among them, from left to right, Arnold Peterson, Philip Lund, and Ferdinand Brochu.

Frank L. Wilcox was born in 1859 in Berlin. He worked at Peck, Stow and Wilcox and became manager there. He served as secretary-treasurer of the Middletown and Portland Bridge Company. As treasurer, he worked in the development of the Berlin Iron Bridge Company. Director of several banks, he was president of Berlin Savings Bank, a legislator, a major in the governor's Foot Guard, and president of the Connecticut Commission to the Louisiana Purchase Exposition in 1904. (Borthwick.)

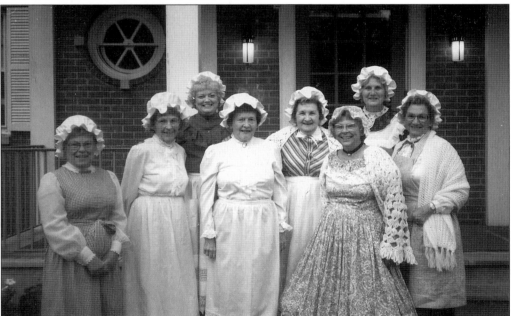

Shown in this view are members of the Kensington Garden Club dressed for the bicentennial celebration. They are, from left to right, Alvina Law, Mildred Meyers, Sandy Quarello, Betty Dodson, Marguerite Swain, Barbara Randall, Dorothy Nappi, and Evelyn Lane.

Blanche Johnson Delaney spent much of her life working through agencies and organizations to improve the community. In 1986, she was appointed by the town and the Kensington Library Society to act as liaison between them, working for the goal of transferring the assets of the society to the town. Coordinating fund drives and grants, she successfully raised over $1 million toward the construction of a new library. She was appointed to the library board and became its chairperson, organizing the board into effective subcommittees, doubling the budget, and establishing policies and job descriptions. The meeting room at Berlin-Peck Memorial Library is named in her honor. (S. Johnson.)

Charles A. Warren (1860–1934) was a bachelor who lived with his sister in a home on Worthington Ridge. The yard contained a tailor shop. (Berlin Free Library.)

Born in Sweden, John O. Johnson came to America in 1871. He devoted his life to the Salvation Army and attained the rank of sergeant major. Johnson, the father of C. Fred Johnson, maintained a home on the Chamberlin Highway. (S. Johnson.)

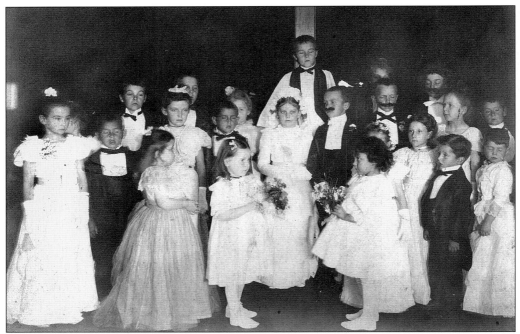

A Tom Thumb wedding takes place at the Berlin Congregational Church. (Berlin Free Library.)

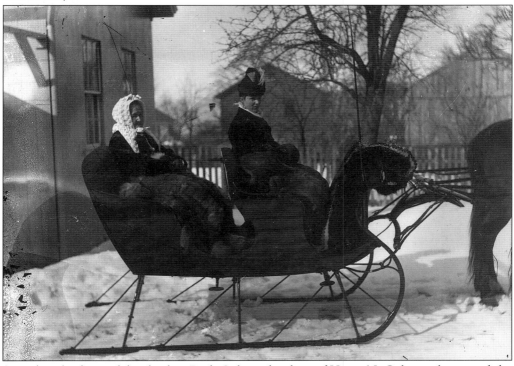

Seated in the front of the sleigh is Ruth Galpin, daughter of Henry N. Galpin, who owned the general merchandise store on Worthington Ridge. (Berlin Free Library.)

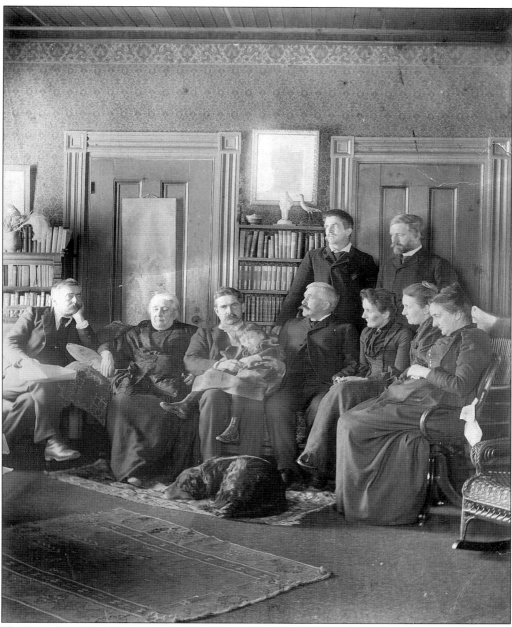

The Brandegee family was an important part of Berlin history. Elishama Brandegee, M.D., was a well-known physician who was very active in encouraging progress in the town. His father ran a store on Berlin Street and had a role in the manufacture of thread. Elishama Brandegee attended Yale Medical School and enjoyed a large practice in Berlin and the surrounding towns. He was instrumental in establishing the Berlin Free Library and was deeply interested in education and the schools of Berlin. He served as treasurer of the school system. He had 11 children, including Robert Bolling Brandegee, a renowned portrait artist, and Emily Victorina Brandegee, who bequeathed her home to the Berlin Free Library. The fine family portrait shows the Brandegees. (Berlin Free Library.)

Lillie Powers wore her "Grandmother Henry Savage's brown taffeta trousseau gown," of Civil War vintage, for an old-fashioned chorus at the Berlin Congregational Church. (Berlin Free Library.)

Three
WHERE WE LIVE

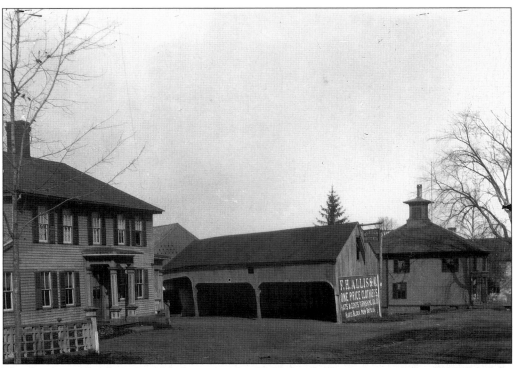

The home in the foreground belongs to the Gold family. It was moved from this location across Farmington Avenue. The next building contained stables, and the building with the cupola housed a dry goods store, owned by James Woodruff. The store has since burned. (Franklin Woodruff.)

The Winchell house in Kensington was built c. 1825. It is a Federal-style home, but has a Victorian wraparound porch and fish-scale shingles on the roof. It sat above the stream overlooking the gristmill, of which Mr. Winchell was half owner with James Gates Percival.

Edward Pattison (Patterson) lived in this home, built before 1721. He was a tinsmith, and his tin shop was likely located across the street. The house was destroyed by fire. (Berlin Free Library.)

Richard Beckley was granted 300 acres of land lying along the Mattabasset River by the General Assembly of Connecticut in 1668. He was the first white settler to live in this area for many years. His land grant was confirmation of ownership of land he had purchased from the Native American chief Tarramuggus, of the Mattabasset tribe. His farmhouse is the oldest home in Berlin. Located in Beckley Quarter, its appearance has changed with renovations. Four front windows were removed and brick facing was applied to the lower portion of the house. The farm contains many greenhouses, which produce vegetable and flower plants for sale to the communities that bound the land.

Originally, this property was occupied by John Dunham, a tinner, and included a tinsmith's shop in the rear yard. Partially destroyed by fire, the house was rebuilt by Timothy Boardman, a tailor, who also kept a shop on the grounds, employing apprentices. The present owners are working to restore this central-hall-style home. (G. Benoit.)

Fireplaces were used in most homes to provide heat during cold weather. This fireplace in the Timothy Boardman home is framed by a mantel and paneled wooden sides. The fireplaces in this house are still used. (G. Benoit.)

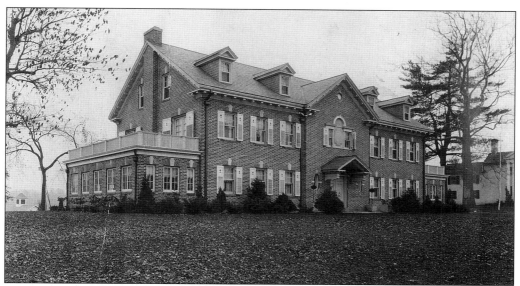

The George E. Prentice house, on Worthington Ridge, was built in the Colonial-revival style. It is one of the largest houses in the Berlin Historic District. George E. Prentice trained in industrial mechanics and founded the G.E. Prentice factory, which made material specialties, fasteners, and zippers. (R. Anderson.)

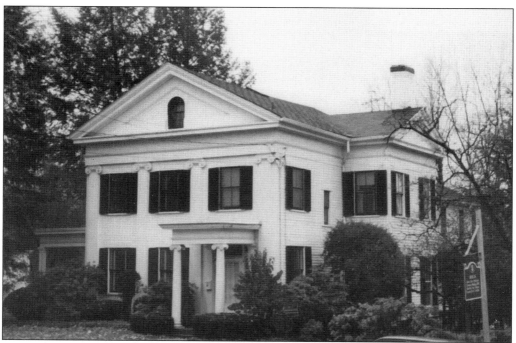

The Elishama Brandegee House is a classic example of Greek revival architecture, with the entry protected by a flat-roof porch held up with Ionic columns. Located in the Berlin Historic District, the house was built c. 1845 for a teacher at Worthington Academy and, following tradition, it is still the home of a teacher and her family. (Berlin-Peck Memorial Library.)

Built near the crest of Mooreland Hill, the 1938 home of William S. Bacon, vice-president and secretary of American Paper Goods Company, is a lovely combination of a fieldstone first-floor exterior with a stucco second floor based on the Tudor style. It has several wings, including a large garage area with several bays. At the rear is found a fieldstone patio. Both floors of the rear of the home are fieldstone.

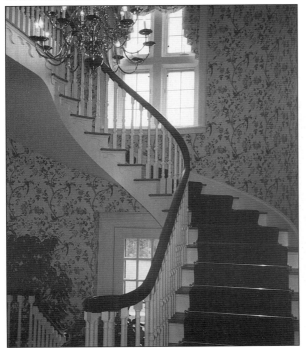

The elegance of the interior of the William S. Bacon home is apparent in this photograph of the gracious, curving staircase and its chandelier, lighting the way to the second-floor living area. The interior has other elegant features: specially designed moldings around the ceilings, a large living room fireplace complete with dumbwaiter to bring up wood, and original and unique doorknobs throughout the house.

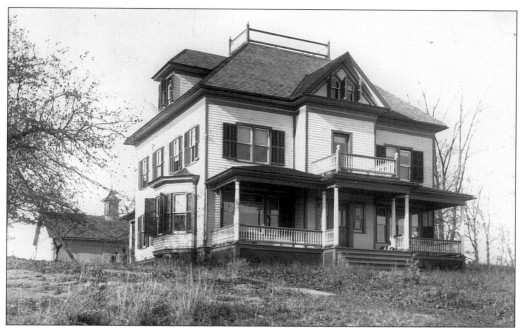

The Emerson house, on Grove Hill, was a large and beautiful home. Built c. 1900, the house had small stained-glass panes above the living room windows. In the living rooms, the floors were done in a symmetrical pattern of hardwood oak. The dining room and kitchen both had pine floors. Seventh-day Adventist meetings were held in the large attic. The barn housed a small paper factory, which made triangular-shaped flat cups. (Berlin-Peck Memorial Library.)

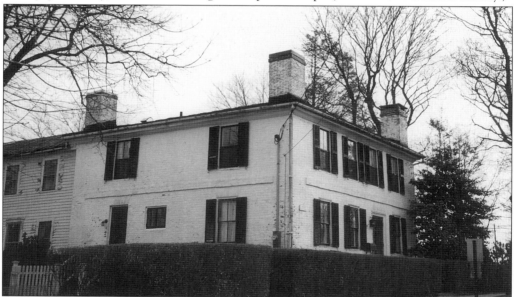

An unusual dwelling, the Jesse Hart House is constructed of brick and is known for having a chimney on each of its four corners, rather than centrally located. Corner fireplaces are found on the interior. A cabinetmaker, Jesse Hart at one time served as postmaster and tavern owner.

Originally a chicken coop on the Wilcox Farm on Sunset Lane, this building has now been converted to a bathhouse. (Janice Anderson Studios.)

Located on Orchard Road in Kensington, this older barn has natural wood and a copper roof. It is still in use today. (Janice Anderson Studios.)

The Ferndale Farm is one of the small farms still functioning in Berlin today. The farm keeps several horses and raises sheep for presentation at fairs, for meat, and for wool. The fenced area in the foreground used to contain enough water for ice-skating in the winter.

Barns were found throughout the three-town area, as this was not only a community of agriculture but also of dairy farms. Many of the old barns have been kept in good repair and are still used. This barn was part of the Shepherd Farm, at the corner of Savage Hill and Spruce Brook Road. (Janice Anderson Studios.)

The Lafayette Gladding House, located at 873–875 Worthington Ridge, was built *c.* 1880. The house is an example of an Italian villa featuring a flat roof. It is decorated with fancy wood trim. In 1984, the house still retained its original doors. (Berlin-Peck Memorial Library.)

Part of what was originally known as the Griswold Farm, this barn sports a cupola, as did many of the barns of the late 19th century. (Janice Anderson Studios.)

Four

A "Fair" Beginning

It all began with squash seeds. A Harvest Festival was organized at Kensington Congregational Church in 1882 by Reverend Benedict in response to a request from a missionary, who passed out squash seeds for the Sunday school children to grow.

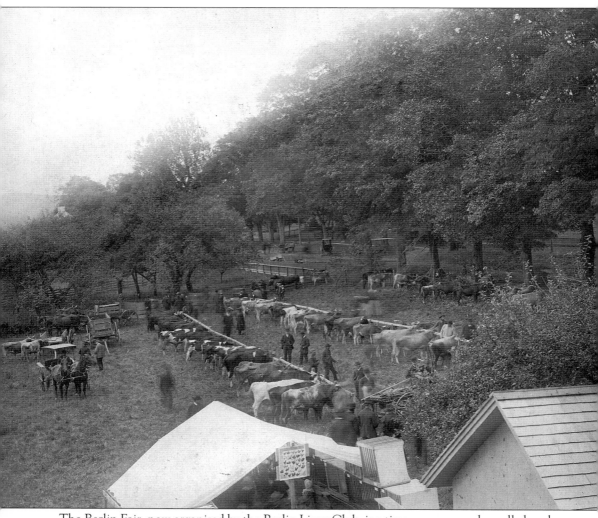

The Berlin Fair, now organized by the Berlin Lions Club, is a time every year when all churches, clubs, and organizations work together for the good of the town. It is one of the "big events" in town life. Held in the town hall in 1883, adults were included and many kinds of seeds were grown. With success came the formation of a Harvest Festival Association and, the following year, an invitation for the town to join. The Berlin Agricultural Society was formed, and the fair was moved to Brandegee Hall. Animals were added to the exhibits, and the fair was moved to the park of the Trotting and Athletic Association. In the early 1900s, the festival became the State Agricultural Fair, held annually until 1919. (Berlin Free Library.)

The first annual Harvest Fair of the Berlin Agricultural Society was held at Brandegee Hall in 1886. Included in the exhibits were field crops, vegetables, dairy and fruit products, flowers, and animals. There was also a baseball game and a tug of war. First-prize premiums averaged 50¢, with a few premiums for special animal categories up to $2. (D. King.)

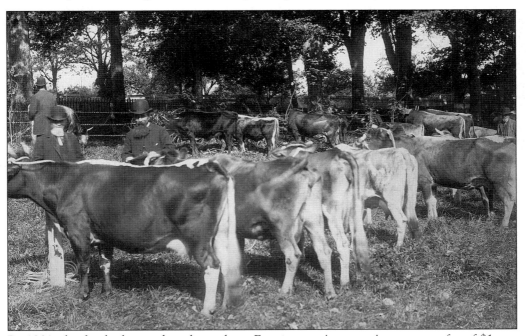

By 1901, the fair had moved to the park on Farmington Avenue. An entrance fee of $1 was charged. Exhibit classes and games were expanded into many more categories, the fair was lengthened to a two-day event, and entertainment was added. However, by 1919, interest in the fair was declining. (Berlin Free Library.)

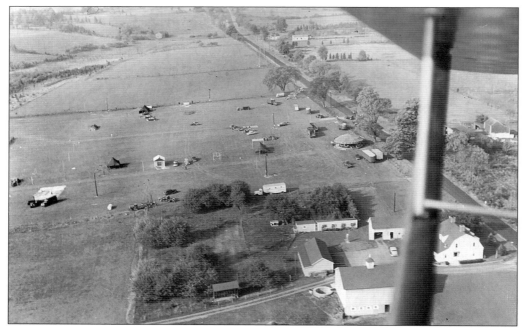

Interest in the Berlin fair rose again during the 1930s and 1940s, although no one group was ready to take on the project. After World War II, the Berlin Lions Club, under the auspices of the Berlin Agricultural and Horticultural Association, organized a new fair. Land was obtained on Beckley Road in East Berlin, and the fair opened on October 6, 1949. The above aerial photograph was taken the day prior to the opening. (Berlin Free Library.)

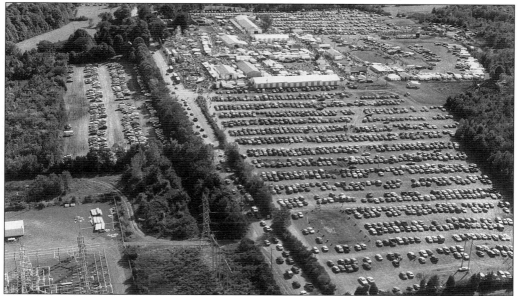

Over the years, incorporation has taken place and many new permanent buildings have been added. The revenue from the fair sustains Berlin Lions Club projects, such as scholarships annually to children, eye research, money to the town for projects, upkeep of the Memorial Pool, and maintenance of the fairgrounds. (Herald / Napierski Jr.)

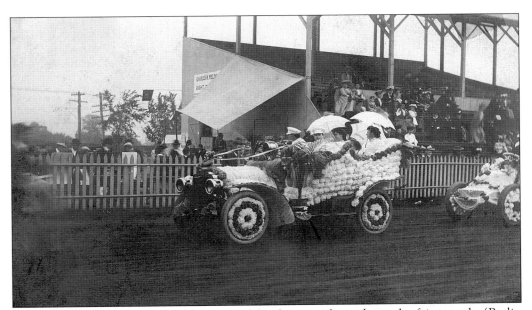

Cars were decorated and floats were created for the annual parade on the fairgrounds. (Berlin Lions Club.)

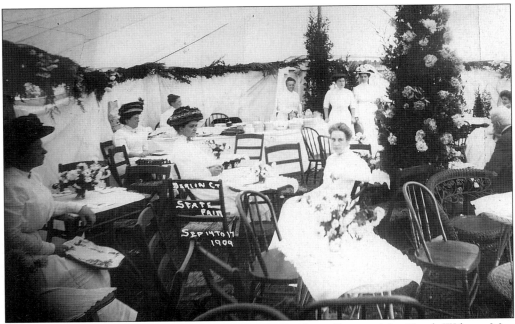

Among those visiting the tearoom at the 1909 Berlin State Fair are Mrs. Frank Wilcox, Mrs. Myron Goodrich, Mrs. Damon North, Mrs. Vile, Mrs. Deming, Mrs. Gray, Harriet Hodge, and Adelaide Deming. (Berlin Free Library.)

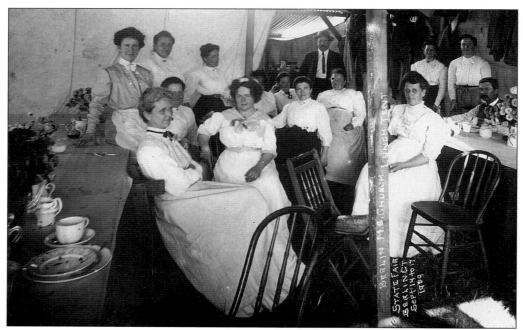

Now that lunch has been served to fair goers, these women from the Berlin Methodist Episcopal Church tent lunchroom take a break before starting the dishes. (Berlin Free Library.)

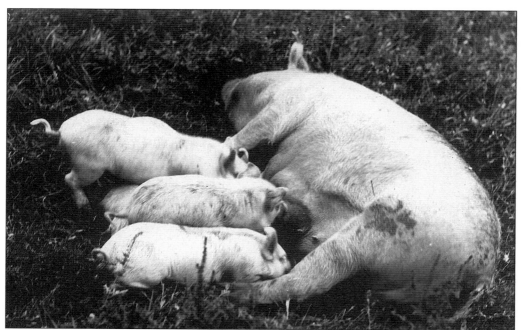

In 1907, folks enjoyed this sow with her piglets enough to immortalize them on a postcard. Today, the pigpen in the sheep barn holds the same fascination for fair goers and, generally, it contains a sow and her piglets to entertain people. (Berlin Lions Club.)

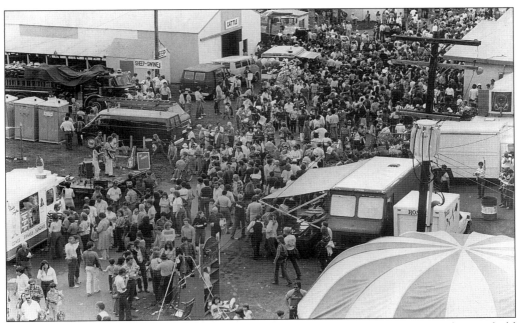

Entries in all categories are submitted on Thursday of the fair weekend, and the judging is held on Friday morning. As evidenced by the crowds in these two 1980s photographs, people are always eager to see who the winners are, visit the exhibits, sample the food, renew friendships, and, of course, visit the midway. (Berlin Free Library.)

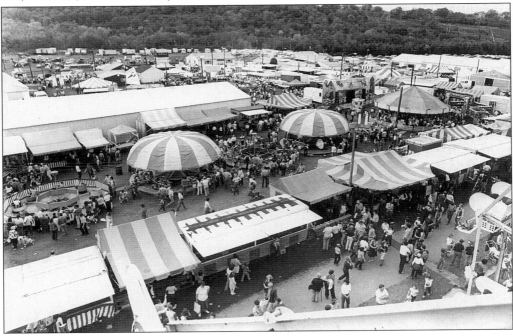

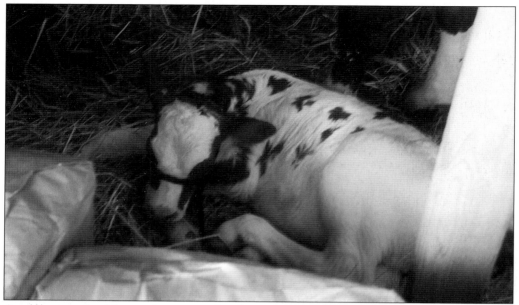

A calf born at the fair was always considered a sign of good luck. In 2000, Miss Berlin was born immediately after her mom was unloaded from the truck, making a trip to the cow barn a very special event. (Berlin Lions Club.)

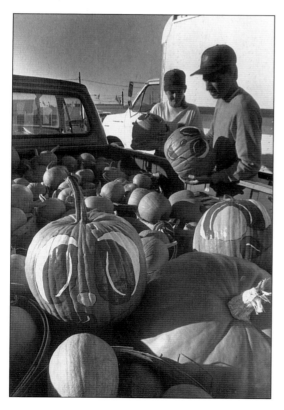

Fruits and vegetables were submitted not only for judging but also for sale by vendors, as seen here. (Herald.)

Children of all ages are encouraged to enter their own crafts, baked goods, floral arrangements, collections, and homegrown fruits and vegetables. One of the favorite contests in all youth age groups is the Potato Pet competition. These creations must be named and be made of a potato and any other fruit, vegetable, or seed combination the child wishes. Nothing artificial can be used. Winning entrants earn prize ribbons and money.

Even toddlers are encouraged to enter toys and drawings. Sometimes, whole preschool groups work on special exhibits. For these two toddlers, ponies brought Melissa a second prize and puppies brought Nichole a first prize.

At earlier fairs, children's exhibits were for penmanship, drawing, sewing, knitting, and patchwork, with first prizes of 50¢ and second prizes of 25¢ . Today, Berlin public offices and schools are closed on the opening Friday of the fair, schoolchildren are admitted free, and midway activities are half price until 6:00 p.m.

In the 1970s, the price of admission rose to $1.50 and the fair ran for three days. Premium rates increased, a men's pie-and-cake-baking category opened, and the Berlin Lions Club began offering scholarships to young men and women planning to continue studies in agriculture or home economics.

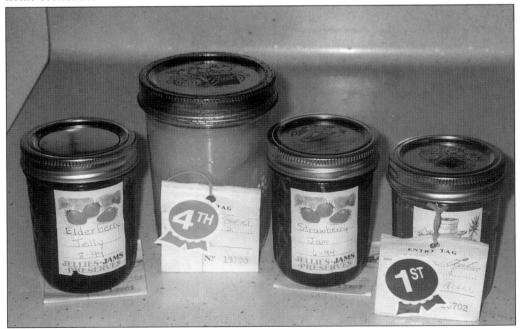

Men and women compete in all kinds of exhibits. A wide variety of canned goods are judged, and each and every entry is tasted. Of note was a State Baking Contest. The winner of the Berlin Fair entry advanced to compete at the state level.

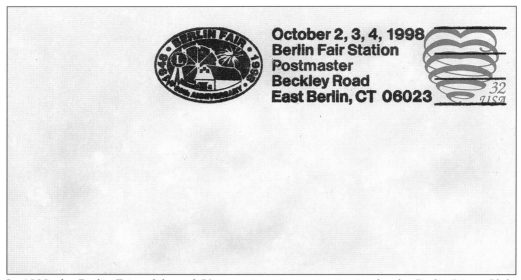

In 1998, the Berlin Fair celebrated 50 years since its reorganization by the Berlin Lions Club. Honoring this occasion, the East Berlin post office opened a branch office at the fairgrounds to provide special cancellations on envelopes and postcards.

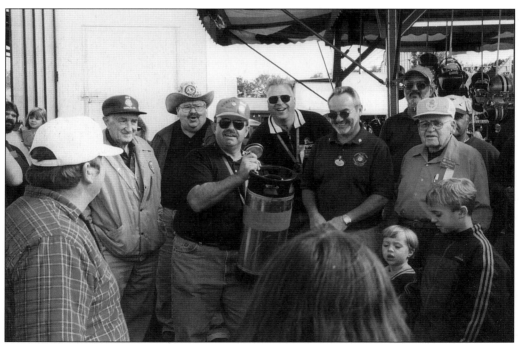

A time capsule, to be opened in 2048 at the 100th anniversary of the fair, was buried behind Memorial Park in 2000. From left to right are the following: (front row) Steve Karp; Ray Riggott; Bob Asal, 2000 fair president; Normand Messier, district governor; and Bob Randall; (back row) Tom Stregowski, Berlin Lions Club president; Paul Kristopik; and Bob Christianson. (Berlin Lions Club.)

Five

TRIPPING THROUGH TOWN

Constructed by American Bridge Company of East Berlin, this bowstring bridge was located on the Mill River, just a few feet west of the curved dam at the site of the Kensington Mill. (Berlin Free Library.)

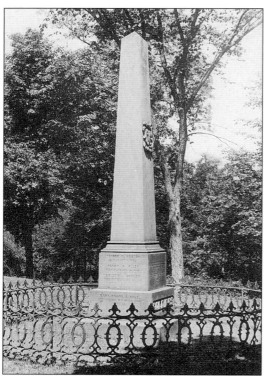

Adjacent to the Kensington Congregational Church is this Civil War Monument, one of the first ones dedicated to the Civil War effort. It bears the names of 15 soldiers from the Kensington Parish. The sandstone shaft was taken from the quarry in Portland, Connecticut, and was brought to Kensington by sleigh and oxen. Nelson Augustus Moore, a resident, designed it. The cost of the monument was $350. (Kensington Congregational Church.)

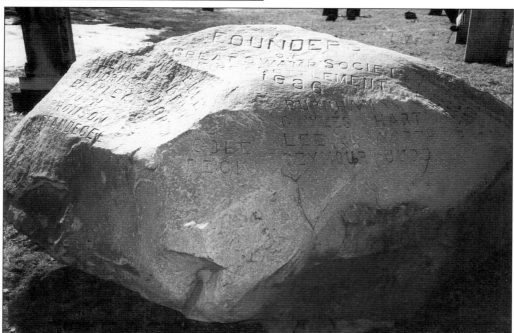

Moved from the S.P. Dunham property, this huge boulder rests inside the gate of the Christian Lane Cemetery. The names of the founding settlers of the Great Swamp Society, settled in 1686, are cut into the rock.

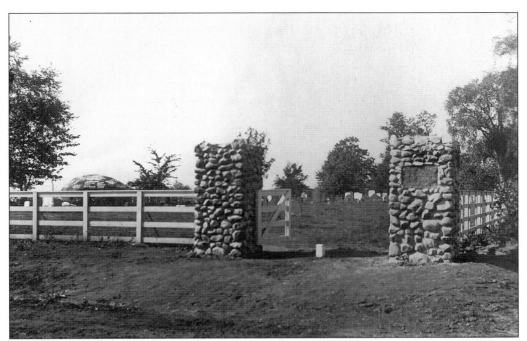

Seen in this view are stone pillars at the entrance to the Christian Lane Cemetery, the first cemetery in Kensington. Capt. Richard Seymour, who brought the first settlers into the area from Farmington, was the first person to be buried in the cemetery. He was killed while felling a tree. (Kensington Congregational Church.)

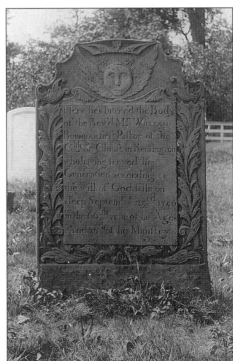

This is the tombstone of Rev. William Burnham, first pastor of the Second Church of Farmington. Located in the Christian Lane Cemetery, the stone is inscribed as follows: "Here lies Interr'd the Body of the Rev'd Mr. William Burnham first Pastor of the Chh of Christ in Kensington who having served his Generation according to the will of God fell on Sleep Septem . . . 23rd 1750 in the 66th year of his Age And 38th of his Ministry." (Kensington Congregational Church.)

79

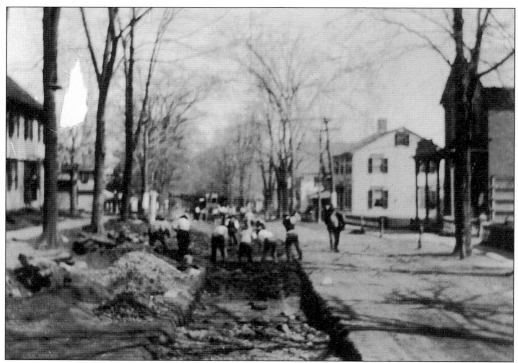

Seen in this view are workers shown laying the trolley tracks on Berlin Street. Trolley cars ran for several decades, finally being replaced in the 1920s by buses. (Berlin Free Library.)

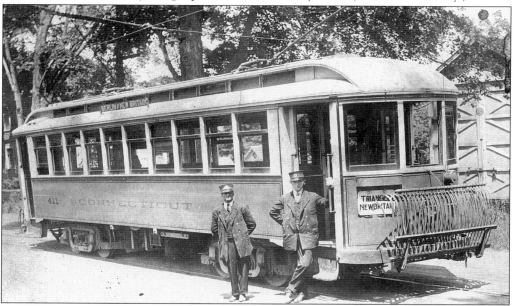

The trolley cars provided transportation between New Britain and Berlin, rumbling as far along the length of Worthington Ridge as the Norwegian-style home just past Middletown Road and, according to *An Historical Sketch of Berlin*, by noted historian Dr. Willard M. Wallace, "often shaking the plaster loose from the ceilings." (Berlin Free Library.)

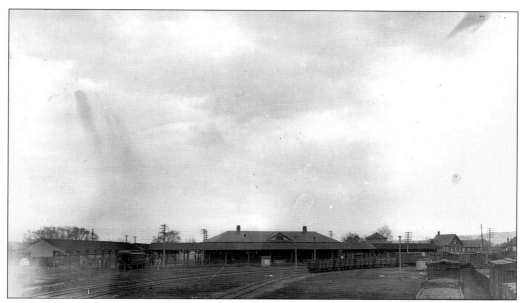

The Berlin Railroad Depot, a one-story building with a low attic, has an office and ladies' room at one end and a freight office at the opposite end. Opened in 1839, it was destroyed by fire and rebuilt several times. Reconstructed in 1893, it is perhaps the most important 19th-century building in Kensington. (Berlin-Peck Memorial Library.)

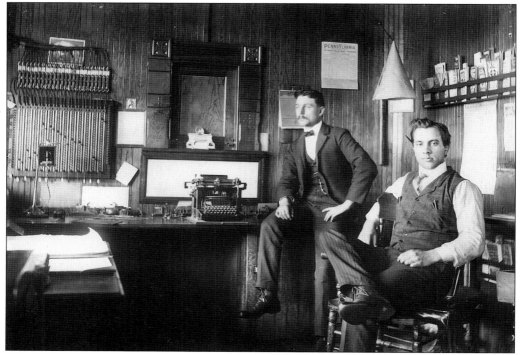

The Berlin Depot ticket office is shown here in 1900. Now owned by Amtrak, the ticket office is one of the few at railroad stations that is still open and retains a stationmaster. (Berlin-Peck Memorial Library.)

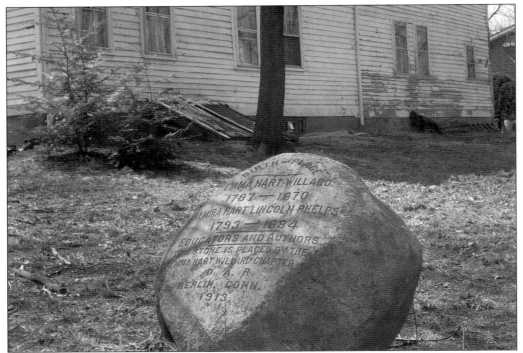

Located in the yard of the Emma Hart Willard House, this boulder commemorates Emma Hart Willard and her sister, Almira Hart Lincoln Phelps, for their contributions as authors and educators. (Berlin-Peck Memorial Library.)

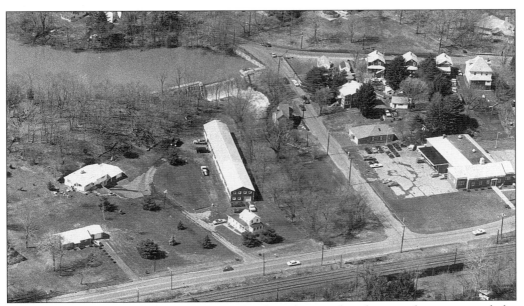

This 1987 aerial view shows Kensington Road, with a poultry farm in the center and the Kensington post office on the right. In the upper left corner are the Railroad Pond and dam on Brook Street. Also visible are some houses on Main Street. (Herald / Chaniewski.)

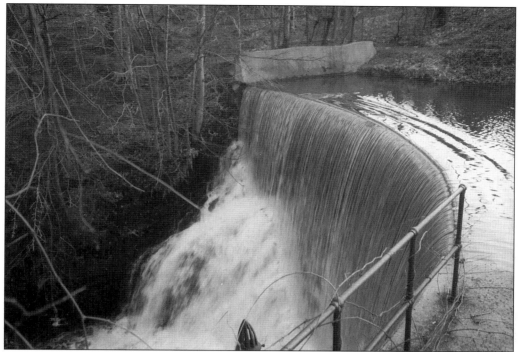

The original dam at this site was low and wooden. This curved gravity dam was one of the first of its kind in the country and the best dam in the state at the time it was built. It was constructed in 1836 of stone and cement by R.A. Moore & Sons to provide a waterpower source for the Kensington Mill. The dam, with its head gates and trash racks, still survives but is no longer used for waterpower.

Once the curved dam was built, a pond formed. The pond became a year-round attraction for people who fished, ice-skated, and boated. Before refrigeration, ice blocks were cut from the pond for iceboxes. Recently, the town bought the area, with the idea of transforming it into a park.

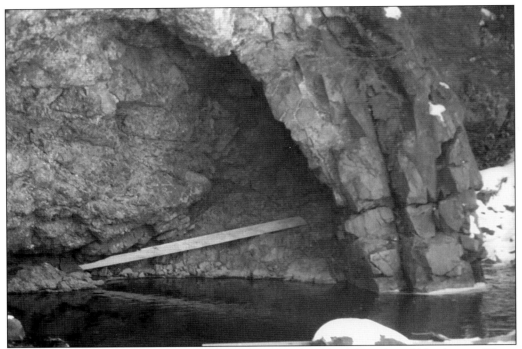

Bullets for soldiers in the Revolutionary War were made of lead from this old lead mine. There is no record of how many bullets were made and no record of any bullets being made after the war ended.

Wedgewood Stables, part of one of the old farms in town, now boards horses. Several years ago, Manes and Motions Therapeutic Riding Center was established here to aid children with disabilities.

The stone marker on the corner of Worthington Ridge and Middletown Road is one of the few markers left from Ben Franklin's time. It shows that the distance to Hartford (H) is 11 (XI) miles. Stagecoach drivers and postal riders used these markers, which were set on the highways near inns to determine how far it was to the next stop.

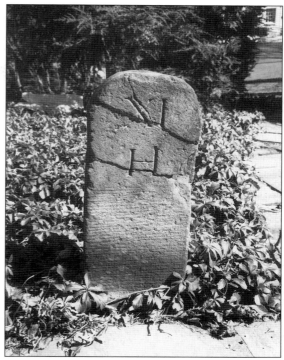

In days gone by, a horse and carriage was a typical means of transportation. Berlin records note that there were only three carriage makers among the industries of the town. (Berlin Free Library.)

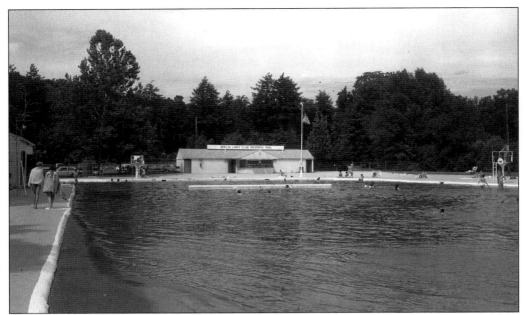

There are two town-sponsored swimming pools, one in Kensington and one in East Berlin. The For more than 50 years, the Berlin Lions Club has cared for this third pool, which is located in Kensington and is popular with the younger set. Years ago, it was a mud-bottomed pool, filled with ice-cold water from an adjacent stream. Today, it is filled with town water. (Berlin Lions Club.)

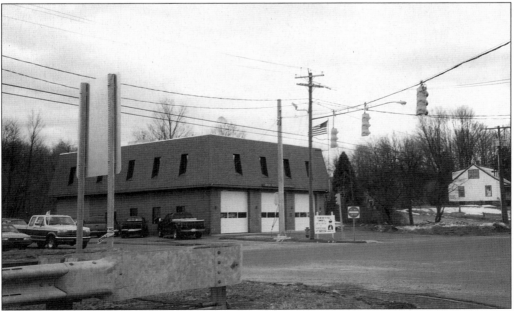

The Berlin Volunteer Fire Department was organized in 1943 with 15 members. The department built its first fire truck from a milk truck donated by Ferndale Dairy and built its firehouse at this location, starting with only one bay, and adding the other bays and the second floor over the years. Today, the town fire department owns the firehouse.

For several years, a Yankee Peddler Day was held on Main Street in Kensington. Artisans displayed their crafts and sold their wares. Everyone enjoyed the treats that were available to eat and had a good time, including young Alan Bickley who visits with Jo-Jo the clown.

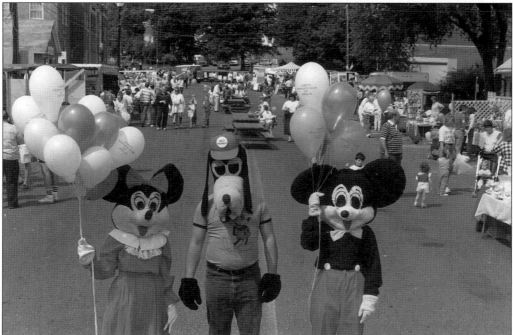

Even Minnie, Mickey, and Goofy were invited to Yankee Peddler Day. A special area was set up behind the Berlin Savings Bank for children's activities, face painting, and pony rides. Main Street was closed to traffic, and people wandered freely. (Berlin Chamber of Commerce.)

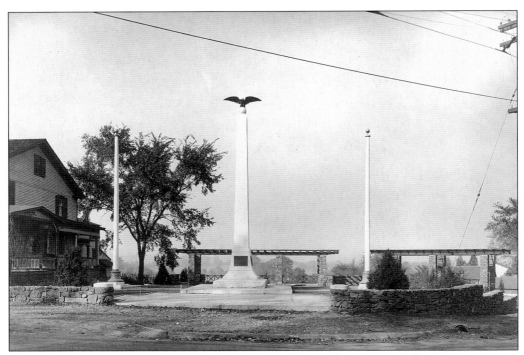

The Soldiers Monument was dedicated in 1920 in honor of residents of the three-town area who served the country as soldiers, sailors, marines, and Red Cross workers in time of war. The site and the parkland were the gift of Maj. Frank Wilcox. (Berlin Free Library.)

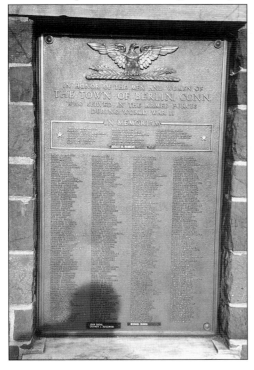

This Roll of Honor, located at the monument, contains the names of veterans who served in World War II. Three matching tablets, mounted in similar fashion, honor veterans from the Korean War, the Vietnam Conflict, and World War I.

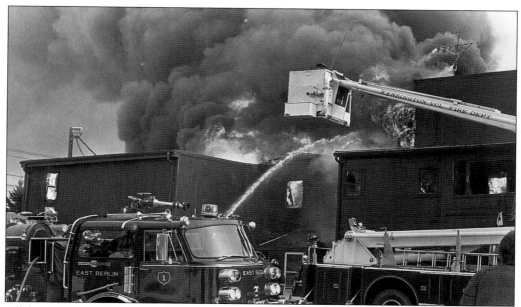

All four volunteer fire departments fought this fire at the Wonder Bar Restaurant for hours on December 27, 1983. The fire destroyed the interior of the structure, leaving a shell that was later torn. (Kensington Volunteer Fire Department.)

Just above this point in the stream are the remains of a dam that created Chisel Pond. Several mills were located in this area.

Even as late as 1931, Mr. Renn had to move hay by horse and wagon from the fields and then unload the hay into a barn for storage. (H. Bacon.)

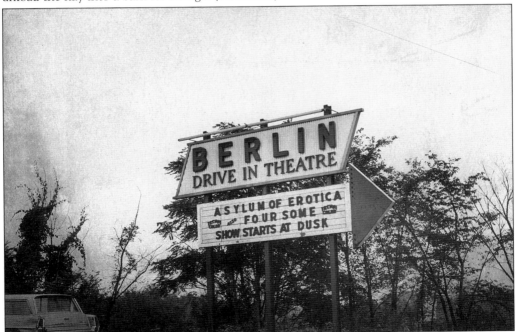

Originally a family theater, the Berlin Drive-In Theatre caused much commotion in town when it changed to triple X-rated movies. Screening fences were put up around the area. Ultimately, the theatre closed. (Herald.)

Due to the distance delay of fire trucks responding from New Britain, East Berlin residents decided to organize their own volunteer fire department in 1932. Responding to its first call with its only piece of equipment, a 50-foot ladder, the department rescued a kitten in a tree. One of the volunteers' first trucks was an early-model Packard hose cart, built by the members. Today, the East Berlin Library is located in the firehouse. (Berlin Chamber of Commerce / Marino.)

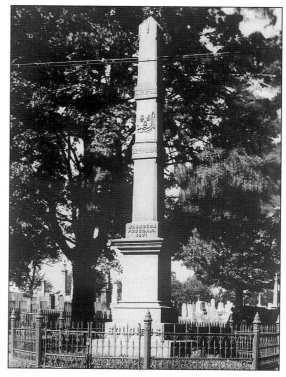

In 1871, the Washburn Post donated the brownstone shaft Civil War Monument, located in East Berlin. It lists the men from East Berlin who lost their lives during the war. Engraved near the top of the monument are the names of four famous battles. (Berlin Free Library.)

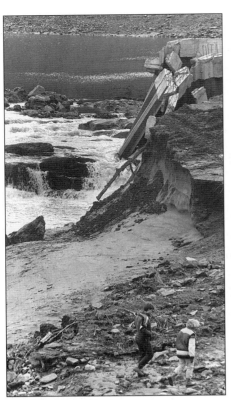

In the early hours of April 1, 1987, the Kenmere Dam broke, sending about one million gallons of water rushing from the reservoir through the spillway into Stockings Brook. An evacuation plan had been drawn up several years prior to that day, after a leak had been found in the earthen dam. (Herald / Chaniewski.)

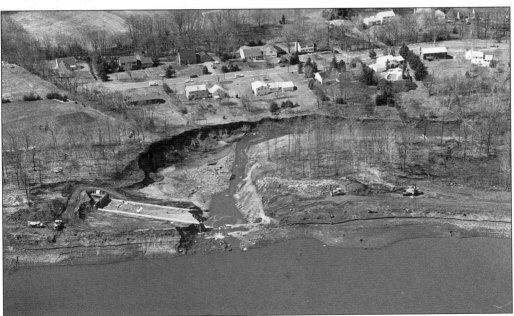

Water pouring from the broken dam followed the natural path of Stockings Brook, necessitating the evacuation of people in the area and resulting in thousands of dollars of damage, especially to Timberlin Golf Course. (Herald / Chaniewski.)

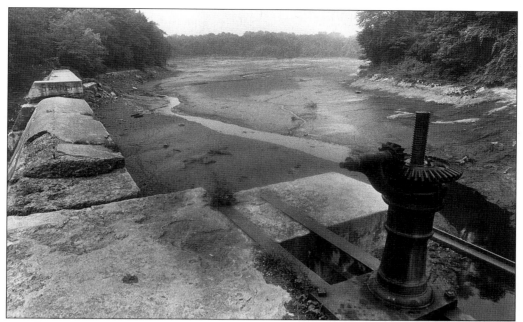

It took several days for the Railroad Pond to be emptied of water in August 1988 to allow repairs to cracks on the face of the dam and replacement of metal parts controlling the floodgates. (Herald / Chaniewski.)

Throughout the three-town area are many streams, small ponds, and swampy places that were once part of the original Great Swamp. Those that remain are often quite lovely to look at.

A notch between two hills was called a "hole." When no more than a wagon trail, this stretch of road was nicknamed the "cat-hole" road. Legend has it that, as people traveled the cat-hole road, wildcats were heard in the hills and cougars were seen on occasion.

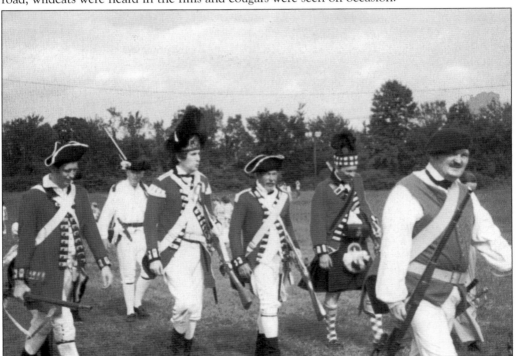

After marching in the Bicentennial Parade, these uniformed and well-trained men arrived at the fairgrounds ready to present a 1776 mock battle. (Berlin Free Library.)

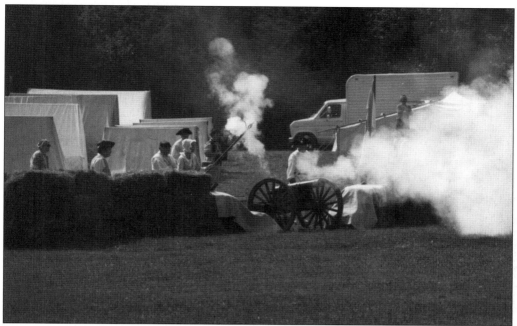

An encampment and mock battle, presented by the Historic Commands of the American Revolution, were part of the bicentennial activities held in 1985. Trained to put on this demonstration, members wore the proper attire and carried the correct type of weapons. (Berlin Free Library.)

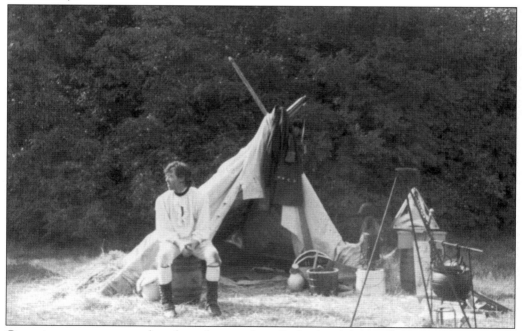

Campsites were set up to show how the men from Berlin lived during the war. The tents were tepee style, the food was cooked in a kettle over a campfire, the kegs and pails were wooden, and light in the evening was from a hanging tin lantern. (Berlin Free Library.)

This is the view from the terrace at the restaurant Timberlin Park. In the distance is one of the Hart's Ponds, usually home to several mute swans. (Berlin-Peck Memorial Library.)

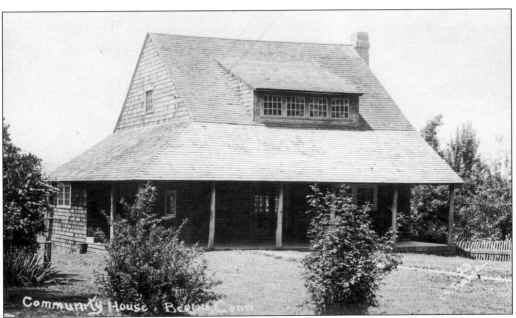

This lovely building on Worthington Ridge served as a local community center for many years. When it was no longer usable, the building was removed and a playground was erected. The community center was then moved to the Kensington Grammar School. Later, it was moved to the lower level of the Berlin-Peck Memorial Library, where it was to be housed until a new community center was built. (Berlin Free Library.)

Six

THE ABC'S OF
INDUSTRY

Early settlers of the town made tinware to replace worn tools and goods and to provide new items for their family and neighbors. As the need for these items became less locally, extra items were placed in baskets and sold farther away from home. (A. Borthwick.)

Founders of the tin industry in the United States were Edward and William Pattison (Patterson), natives of Ireland. For many years, tin making was confined to Berlin and the town became well known for its tin products. After the Revolutionary War, products were carried by carts and wagons to be sold all over the country, and the term "Yankee peddler" was coined. Thin scraps of tin, discarded out shop windows, were picked up by children, who took them home to decorate their Christmas tree—the first "tincycles." (A. Borthwick.)

The sign on this 1923 bridge shows that Berlin Construction Company of Berlin was the builder. Many bridges built by this company can still be seen in the United States—in New York, for example, and even in Texas. (Berlin Chamber of Commerce.)

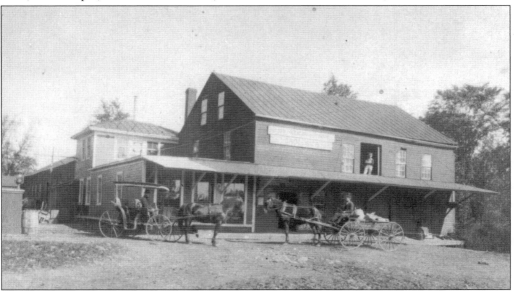

East Berlin Milling Company was built in 1771 by David Sage Jr., Daniel Wilcox Jr., and Josiah Wilcox. The company produced cotton and woolen yarn. Local women then spun the threads and yarns into blankets and clothing. The company continued in business well into the 1800s. (Berlin Free Library.)

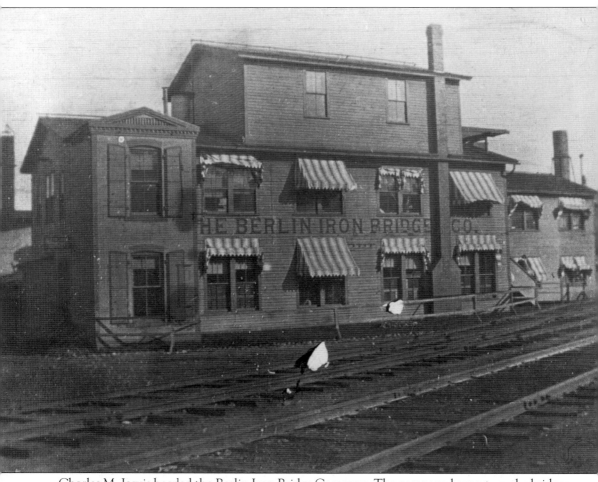

Charles M. Jarvis headed the Berlin Iron Bridge Company. The company began to make bridges in 1870 and, at that time, employed about 20 men. In 1901, Jarvis combined this company with several other companies to form the American Bridge Company and, in addition to bridges, began to manufacture corrugated shingles, fireproof shutters, doors, and roofs. The company now operates as Berlin Steel Construction Company, manufacturing and erecting structural steel for parabolic truss bridges and steel-frame buildings. (Berlin Free Library / Darnell.)

In the cellar of his home, Horace Raymond and Evert Blomgren started what was to become Raymond Engineering. From that cellar, they moved to this bungalow and then to Middlefield. Their work with an already existing technology resulted in the creation of the electric-eye door as we know it today. (E.S. Benson.)

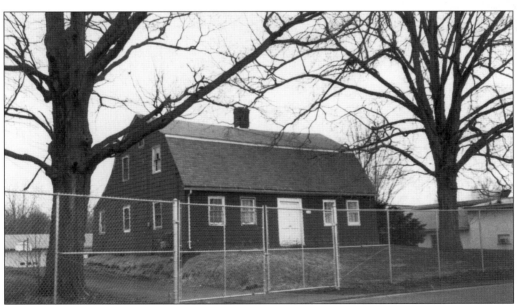

Built in the late 18th century and purchased from Seth Deming, this building became the Berlin Alms House, also known as the Berlin Town Farm. At one point it also housed the town jail. A door from the building is on display at the Berlin Historical Society Museum.

The pro shop and restaurant are busy places at Timberlin Park. Golf, tennis courts, blue-trail hiking, cross-country skiing, picnic areas, wooded trails, parking, and the shops are available to everyone. (Berlin Chamber of Commerce.)

Town Place is one of the newer commercial buildings in town. It houses a variety of offices, including that of the Berlin Chamber of Commerce. (Berlin Chamber of Commerce.)

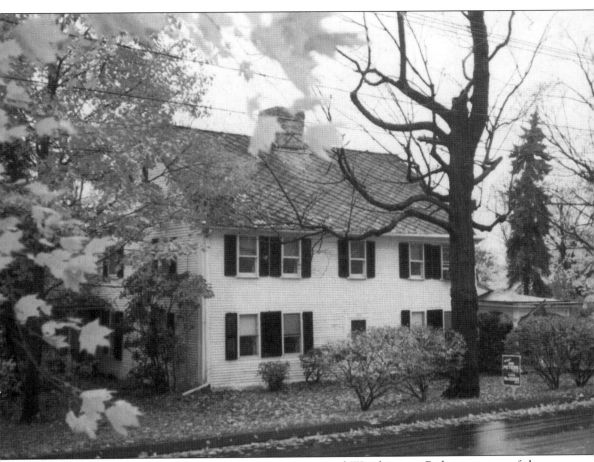

Fuller's Tavern, located on the corner of Sunset Lane and Worthington Ridge, was one of the stagecoach stops in Berlin. An entry in George Washington's diary shows that he "breakfasted at Worthington, in the township of Berlin, at the house of one Fuller" on November 18, 1789. (The Berlin News, *Other Times, Other Voices*, by Doris Meyers, page 45.) The original clapboards were held in place by hand-wrought nails. The inn contained a ballroom which, when renovated, revealed a painted wall containing Masonic symbols. The ballroom is believed to have been the meeting place of Harmony Lodge of New Britain, established in 1791. (Berlin-Peck Memorial Library.)

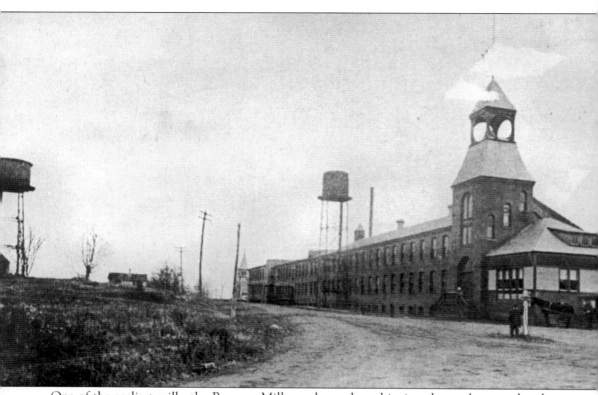

One of the earliest mills, the Bronson Mill, was located on this site where a low wooden dam was built across the river. The property changed hands several times, becoming Hart Manufacturing Company, where general hardware was manufactured. Twice the wooden buildings burned down, finally being replaced by this brick building with a slate roof. American Paper Goods Company was formed in 1893 to make open-end envelopes and waxed paper bags for tobacco and seeds, photograph enclosures, proof-mailing envelopes, and bags for scissors, among a large variety of other paper products. Offices were located in the tower, overlooking the lake created by the new dam. A number of other buildings surrounded the factory, used for such things as storage and a fire pump house. In the early 1900s, the building was sold to Continental Can Company. Today it is owned by Sherwood Tool Company. (Berlin Free Library.)

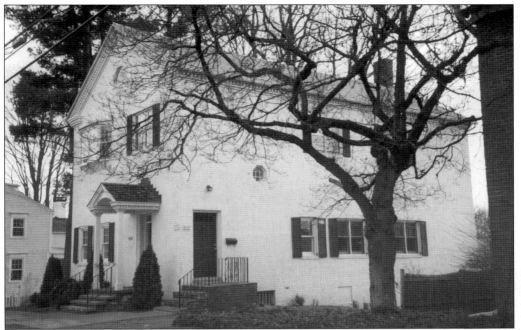

This brick building was a general merchandise store, managed by Orin Beckley and later by Henry Norris Galpin. For a period of time, it also contained the post office. In 1861, the store burned but Galpin rebuilt and resumed his business at the same place. Today, it is a private residence.

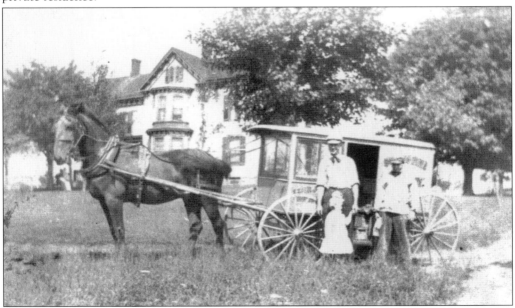

The Springdale milk wagon, owner C. Fred Johnson, and his daughter Blanche are ready to deliver milk. Johnson used to cut ice from local ponds and store it with sawdust between the ice blocks to keep his milk cool during the summer. Cream had to be separated from the milk by a hand-crank separator, and bottles had to be washed by hand. (S. Johnson.)

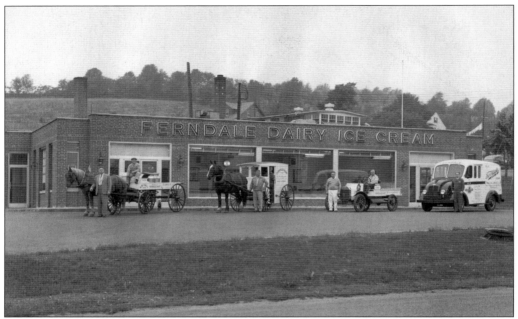

Ferndale Dairy operated in Kensington for 37 years, delivering some 250 quarts of milk a day in bulk by horse and wagon. Later, glass bottles were introduced, washed at first by hand and then by a revolving brush. Pasteurization was initiated after 1932. In 1947, the ice-cream and lunch bar opened in front of the dairy. (Hall.)

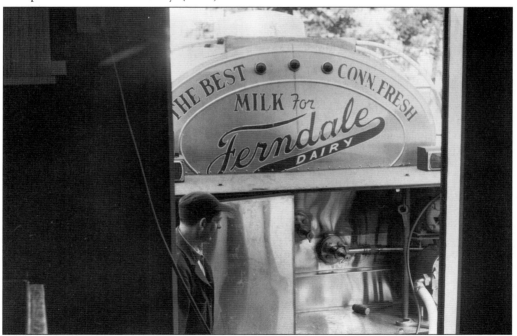

Ferndale Dairy was partially destroyed by a raging fire in 1969, with damage in excess of $150,000. It took the efforts of all four fire companies, using about 100 men, plus assistance from New Britain and South Meriden, to bring the fire under control. (Hall.)

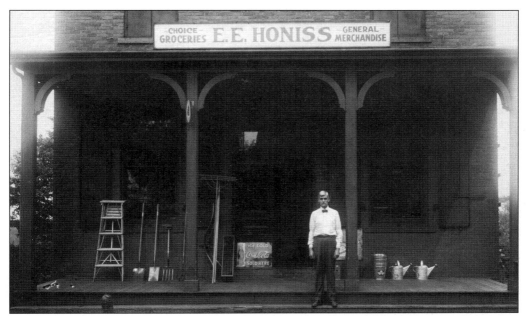

Edward E. Honiss operated a grocery and general merchandise store in the East Berlin section of town. He purchased the store from Henry Galpin in the early 1900s. In addition to groceries, the store sold fruits, seed, agricultural implements, hardware, wire fencing, and poultry netting. The Honiss family also had interest in a flour mill and gristmill. Honiss attended Hannum's Business College and then became bookkeeper for his uncle at the mill prior to owning the store. (E.S. Benson.)

Opened in 1796 by Benjamin Galpin, the Berlin Hotel became a favorite resort to visit. It burned in the 1800s. Rebuilt by Jesse Hart, it had 24 rooms, a ballroom, and barns. A small stagecoach ran back and forth between the hotel and the railroad depot, with horses struggling through the mud in the spring. The hotel held sleighing parties in the winter and, on occasion, it hosted weddings. The post office occupied one room for many years. (Berlin Free Library.)

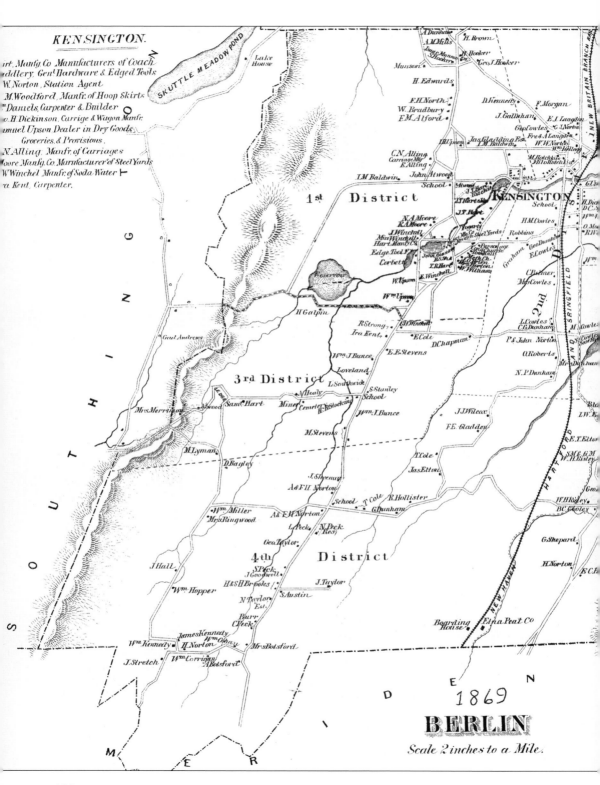

KENSINGTON.

...art, Manfg Co Manufacturers of Coach
...ddlery, Gen'l Hardware & Edged Tools
...W. Norton, Station Agent
...M. Woodford, Manfr. of Hoop Skirts
..." Daniels, Carpenter & Builder
...o.H. Dickinson, Carriage & Wagon Manfr.
...amuel Upson Dealer in Dry Goods,
 Groceries, & Provisions.
...N. Alling, Manfr. of Carriages
...oore Manfg.Co. Manufacturer of Steel Yards
...W Winchel Manfr. of Soda Water
...ra Kent, Carpenter.

SKUTTLE MEADOW POND

Lake House

SOUTHINGTON

1st District

KENSINGTON

Munson
H. Edwards
F.H.North
W. Bradbury
F.M.Alford
C.N.Alling
Carriage Mfr.
E.Alling
I.M.Baldwin
John Atwood
School
A.Dunham
A.M.Mills
H.Brown
Jas.G.Manson
Hooker
Geo.I.Hooker
D.Kennedy
F.Morgan
J.Gallahan
E.I.Langdon
Geo.Cowles
C.Norton
Fred A.Langdon
W.W.Norton
Jas.Gladding Est.
I.M.Baldwin
Hill.Upson
M.Hotchkiss
J.W.Hotchkiss

N.A.Moore
K.A.Moore
J.Winchel
Miss Woodford
Hart Manfg.Co.
Edge Tool Fy.
Corbett
John
T.R.Hart
E.Winchel
W.Upson
Wm.Upson
H.Galpin
R.Strong,
Ira Kent,
A.F.Winchel
E.Cole
D.Chapman
H.M.Cowles
Robbins
Graham
Geo.Dunham
E.Cowles
C.Palmer
Mrs.Cowles
L.Cowles
C.G.Dunham
O.Roberts
P.& John Norton
N.P.Dunham
Mrs.Dunham

2nd DISTRICT

SPRINGFIELD
HARTFORD AND
M.Cowles
Cowles
Scovil

NEW BRITAIN BRANCH R.R.

Reservoir

3rd District

Gad Andrews
Mrs.Merriman
Atwood
Sam'l.Hart
Miner
Cemetery
A.Healy
L.Southwick
H.B.Stocking
Wm.J.Bunce
Loveland
S.Stanley
School
Wm.J.Bunce
E.E.Stevens
J.J.Wilcox
F.E.Gladden
M.Stevens
T.Cole
Jas.Etton
M.Lyman
D.Bagley
J.Stevens
A.& F.H.Norton
School
T.Cole
R.Hollister
G.Dunham
R.E.T.Elton
S.M.C.G.M
W.H.Risley
Geo.
W.H.Risley
B.C.Cooley

SOUTHINGTON

4th District

Wm.Miller
Mrs.Ringwood
A.& F.H.Norton
L.Peck
N.Peck
Res.
Geo.Taylor
J.Hall
Wm.Hopper
S.Peck
J.Goodwell
H.& S.H.Brooks
N.Taylor
Est.
Burr
C.Peck
J.Taylor
S.Austin
G.Shepard
H.Norton
E.C.H.

James Kennedy
Wm.Cowles
Wm.Kennedy
H.Norton
Mrs.Botsford
J.Stretch
Wm.Corrigan
J.Botsford

Boarding House
Etna Peat Co

NEW HAVEN

M E R I D E N

1869

BERLIN

Scale 2 inches to a Mile.

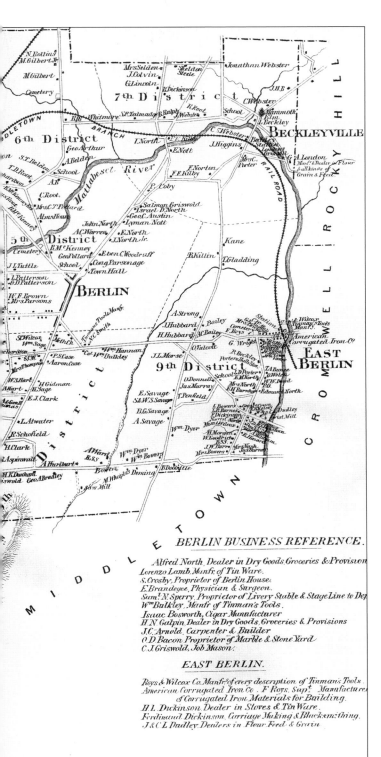

BERLIN BUSINESS REFERENCE.

Alfred North, Dealer in Dry Goods, Groceries & Provision
Lorenzo Lamb, Manfr. of Tin Ware.
S. Crosby, Proprietor of Berlin House.
E. Brandegee, Physician & Surgeon.
Sam! N. Sperry, Proprietor of Livery Stable & Stage Line to Dep
Wm Bulkley, Manfr of Tinman's Tools.
Isaac Bosworth, Cigar Manufacturer
H N Galpin, Dealer in Dry Goods, Groceries & Provisions
J. C. Arnold, Carpenter & Builder
O. D. Bacon, Proprietor of Marble & Stone Yard
C. J. Griswold, Job Mason.

EAST BERLIN.

Roys & Wilcox Co. Manfr. of every description of Tinman's Tools.
American Corrugated Iron Co. F Roys, Sup! Manufacturer
of Corrugated Iron Materials for Building.
H L. Dickinson, Dealer in Stoves & Tin Ware.
Ferdinand Dickinson, Carriage Making & Blacksmithing.
J. & C. L. Dudley, Dealers in Flour, Feed & Grain

An industrial map from 1869 shows several railroad lines, only one of which still operates. The line marked Hartford and Springfield is part of the current Amtrak service. (Berlin-Peck Memorial Library.)

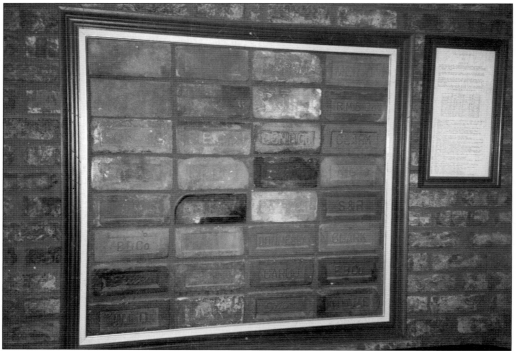

Due to the large amount of clay in its soil, the Berlin area was ideal for making bricks. As many as 26 brickyards operated in Berlin from 1880 to the mid-1900s. The workers were mostly immigrants. Bricks from Berlin were shipped throughout New York and the eastern seaboard. Joan Teske collected bricks from local brickyards for this commemorative wall in the Berlin Town Hall.

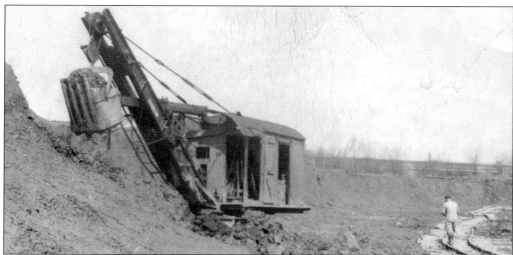

Travelers heading down Route 9 in Berlin can see the top of a crane sticking out of a pond. The scene has caused many comments. Pictured above is the same crane, Owned by the Donnelly Brick Company, it was used to dig clay from the pits to make bricks. The story is told that while digging one day, the shovel hit a large spring, and the hole filled with water so quickly that the company could not get its crane out. (King.)

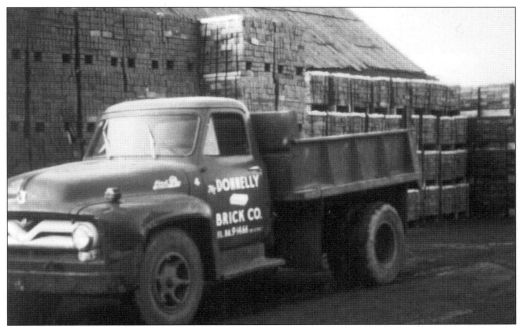

Brick making was a major industry for over 80 years. The Donnelly Brick Company, owned by three brothers, functioned until 1958. At the peak of production, one of the brick companies utilized 90 men per day making 90,000 bricks each day. "Inside" bricks in the 1930s sold for $15 per 1,000, and the best "outside" bricks sold for $25 per 1,000. (J. Teske.)

As families moved into the Great Swamp Settlement and then expanded farther into the area to settle the town, it was the business of the women to spin wool, weave cloth, and make clothes for their families. Cottage industries, many with apprentices, functioned in homes and backyards throughout the 18th and 19th centuries. (Berlin Free Library.)

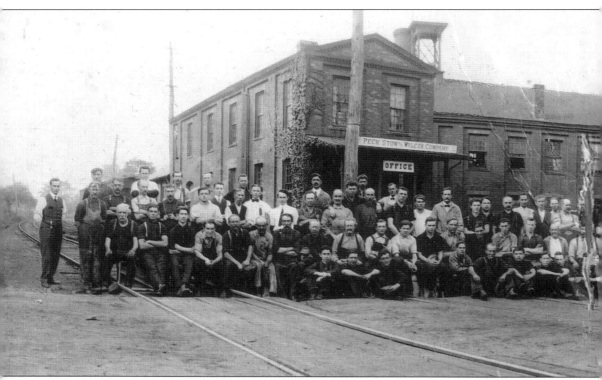

Elias Beckley Jr. brought the craft of toolmaking to Berlin. After the Revolutionary War, most tools were made from imported tinplate. As tinplate was replaced by sheet metal, tools and machines had to be adapted to the new metal. Seth Peck patented the first sheet-metal folding machine, increasing production. Machines were operated by hand and foot power. Shipments were by horse teams and canal and then railroad. Solomon Stow's shop made forming and

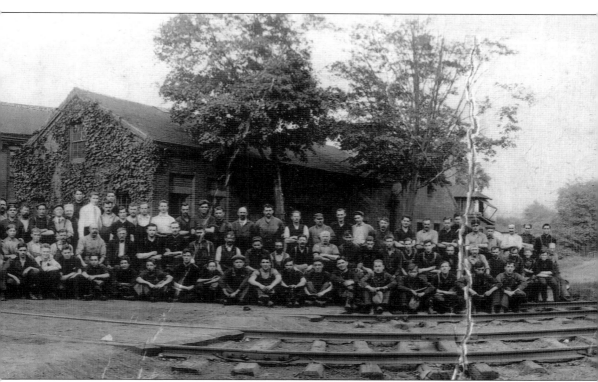

beading machines, which allowed production of a full line of sheet metal worker's machinery. Roys and Wilcox manufactured tinners' tools, making the first squaring shears in the United States, followed by the first foot-treadle shear. Business was expanded to include a forge shop, a foundry, and a machine shop. These small job shops and many others were merged together in 1870 to form the Peck, Stow, and Wilcox Company. (H. Bacon.)

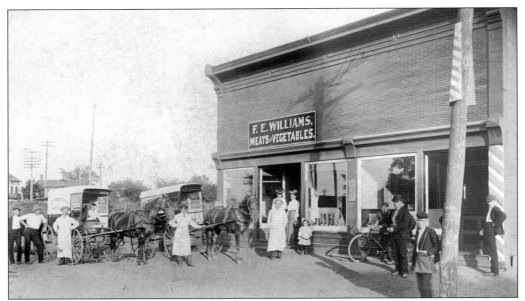

Freeman Williams's store carried meats and vegetables, which were loaded daily onto the two wagons shown and driven around town, Yankee-peddler style, selling the contents to housewives. Pictured, from left to right, are Bud Hartney, Jack Hackett (constable) Ernie Williams (Freeman's son), Ester Williams (sitting in the cart), Ray Williams (Freeman's son), Freeman Williams, Josie Williams, Hattie Williams (wife of Freeman), and Marion Williams. With the bicycle are William Sanford, Dick Brown, and Billy O'Brien. (E. Williams.)

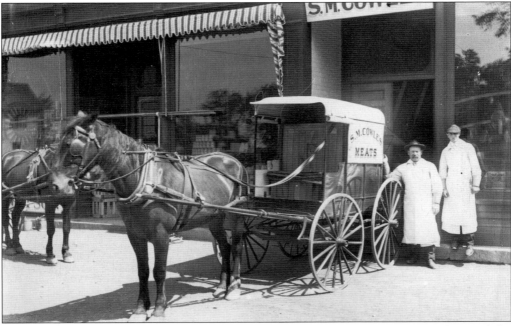

S.M. Cowles Market was located on Main Street in Kensington. S.M. Cowles also used the Yankee-peddler method of horse and carriage for the sale and delivery of meats. The store was eventually sold to make room for the Berlin Savings Bank. (Berlin-Peck Memorial Library.)

Seven

CHANGING TIMES

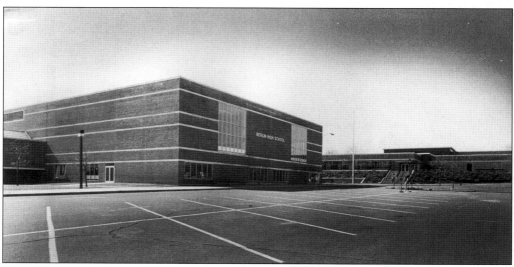

The oldest part of the new Berlin High School was opened in 1953, with an addition in 1975. In 1989, enrollment went over 700 pupils and continued to rise. The high school is fully accredited and, in addition to academic studies, offers courses in art, music, industrial arts, and languages,—a total of more than 150 courses. It also offers college credit courses in English, biology, mathematics, and sciences for upperclassmen, as well as many extracurricular activities. Sports continue to be an important part of school life. (Berlin Free Library.)

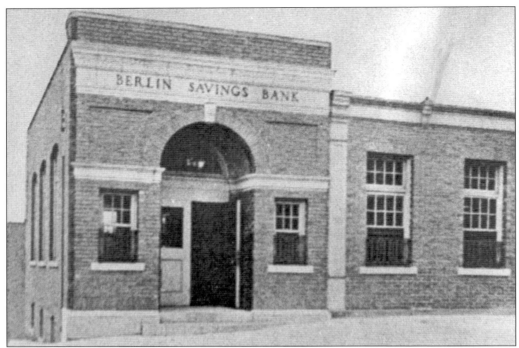

The Berlin Savings Bank was organized in October 1873, with Alfred North as its first president, Henry N. Galpin as vice president, and Theron Upson as secretary-treasurer. The bank was robbed so many times that in the 1940s, when it was rebuilt, the owners made it bulletproof. (Berlin Free Library.)

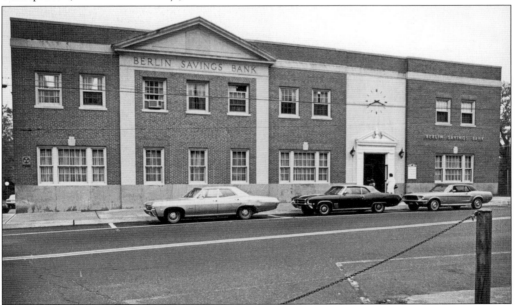

By 1973, Berlin Savings Bank had expanded to this building, with offices in Webster Square, Ferndale Plaza, and Rocky Hill. Sold several times since then, the bank is now part of Webster Bank. (R. Anderson.)

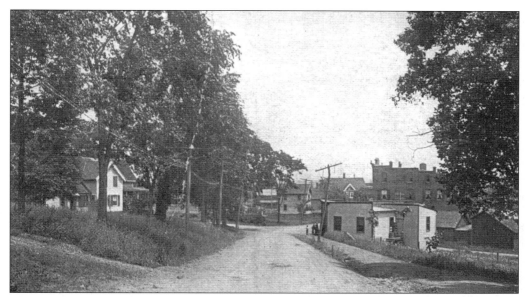

This view looking northeast from the Kensington Library shows Main Street in Kensington. A small park has replaced the little white store in the foreground (Pop Anderson's store), where penny candy could be bought, even into the 1940s. (Berlin-Peck Memorial Library.)

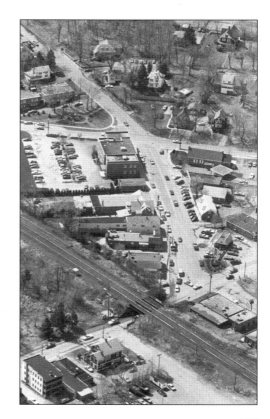

Looking northeast, a more recent view of Main Street shows a much built up Main Street area. The large building in the center is Webster Bank, to the lower left is a hotel, and to the lower right is Berlin Heat Treating. (Herald / Chaniewski.)

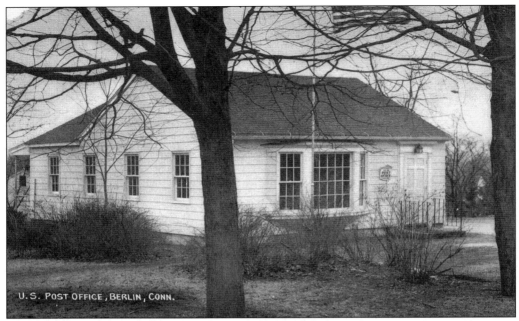

Early post offices in Berlin were usually found in a corner of a general store or in a hotel. This small post office still functions on Worthington Ridge. (E.S. Benson.)

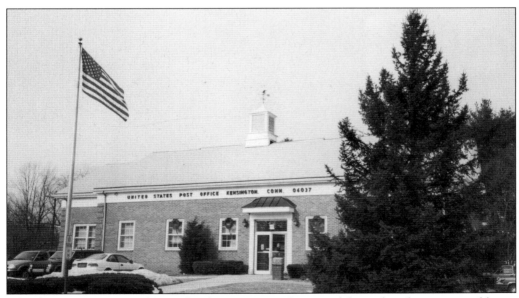

Mail for the 06037 zip code area (Berlin-Kensington) is now delivered to this newer and larger post office in the Kensington section of town. East Berlin, with its 06023 zip code, maintains its own post office.

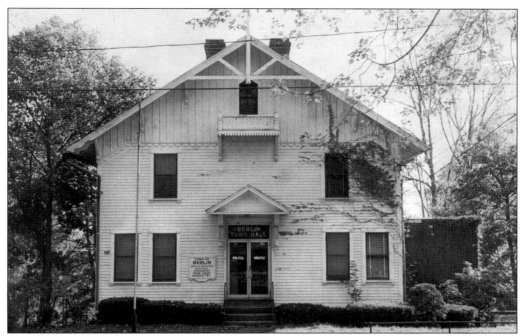

Brandegee Hall, built in 1864, was originally used as an entertainment site and for roller-skating. In 1907, it was taken over by the town and used as the town hall. Today, it is privately owned. (Herald.)

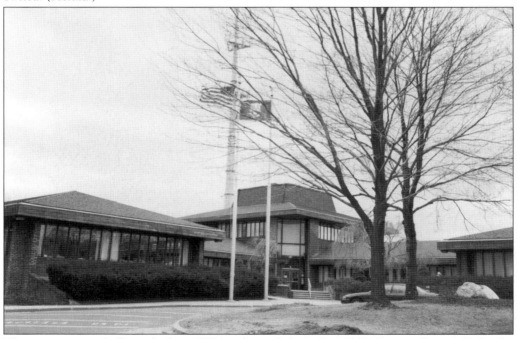

The present town hall was built in 1974 and was dedicated in 1975. It is used not only by the town for its offices but also by the Berlin Board of Education, the Berlin Public Health Nursing Service, and the Berlin Police Department.

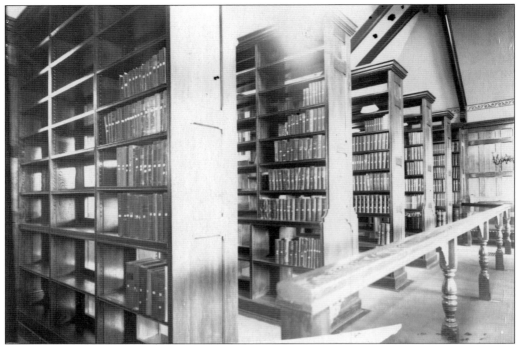

In 1829, the Kensington Library Association asked permission of Kensington Congregational Church to be allowed to keep its books in the church as a beginning of a library. A cupboard under the stairs was assigned for this purpose. The librarian earned a salary of $2 per year. A total of 36 people joined the library, paying a membership fee of $2 each. By the time Peck Memorial Library needed further expansion, it housed over 2,000 books. (Berlin-Peck Memorial Library.)

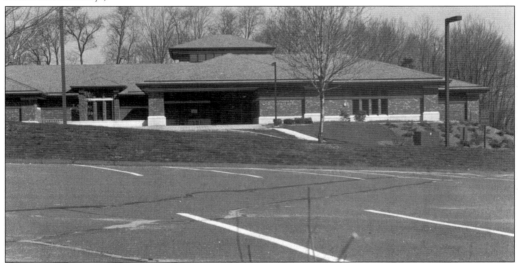

Today's library, the Berlin-Peck Memorial Library, was opened in 1989 and houses a collection of some 90,000-plus volumes, serving as the main library for the Kensington, Berlin, and East Berlin area. Other smaller libraries are found on Worthington Ridge and in East Berlin. (Berlin-Peck Memorial Library.)

Timberlin Park, in addition to the facilities mentioned on the sign—18-hole public golf course, clubhouse, restaurant, picnic grounds, tennis courts—has walking trails, a pavilion, and places to go and just sit for the quiet pleasure of being there. Swans grace the nearby pond. (Berlin Chamber of Commerce.)

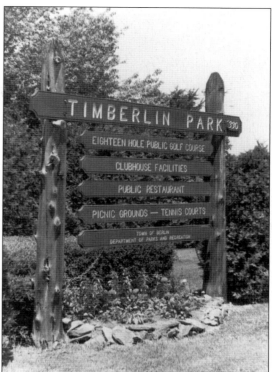

The 18-hole golf course at Timberlin Park is a favorite among residents and nonresidents and hosts many tournaments every year. (Berlin Chamber of Commerce.)

This class attended the private school of Helen Roys, located on the corner of Hudson Street and Worthington Ridge. (Berlin Free Library.)

This is the Class of 1935 reunion of the above class at Miss Roy's school. Shown, from left to right, are the following: (front row) Oscar Benson, Joseph Kamenski, and John McGee; (middle row) Ralph Carter, Lillie Burnham, Mrs. Cooley (teacher), Sadie Weldon Hyde, Olive Shaw, and Bessie Benson; (back row) Bill Retz, Edward Michael, Mrs. Edward Michael, Elsie Norton, R.C. Hurlbert, Ethel Burnham, Walter Bunce, Olaf Benson, Ethel Hart Hanford, and Flora Norton. (Berlin Free Library.)

Charles Claudelin, who lived on Kensington Road in the mid-1920s, had children who attended school several miles away. He began driving them and, eventually, started picking up other children on the way. According to the family, the town began to pay Claudelin to transport the children, making him possibly the town's first school bus driver with the town's first school bus. (H. Bacon.)

Today, the town contracts private companies to provide school bus transportation for schoolchildren throughout the entire three-town area.

In 1972, the Berlin Conservation Committee acquired 117 acres of land east of Route 15 to be preserved forever as a park for recreational use. The committee acquired the land from Henry Sage of California, and the town created Sage Park. In addition to athletic fields, the park offers a fishing pond, ice-skating, sledding, and a picnic area.

As the high school expanded, Sage Park became the permanent home of the athletic department. Bleachers, a football field, and two baseball fields were constructed.

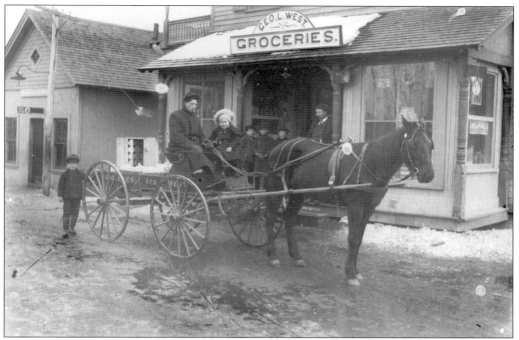

Because the town was an agrarian and farming community, many of the products people needed were homegrown. As small grocery and general merchandise stores appeared, more products became available commercially to homeowners. (Berlin-Peck Memorial Library.)

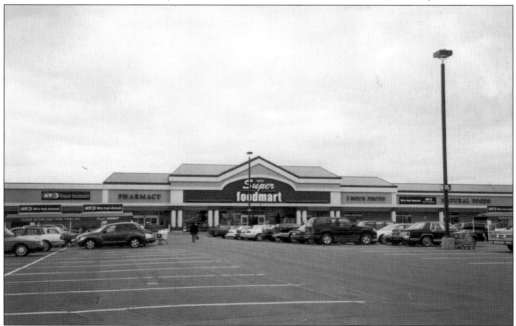

Today, several large supermarkets containing thousands of products offer such amenities in one location as groceries, general merchandise, pharmacy availability, flowers, and prepared meals, along with the convenience of extended 24-hour service.

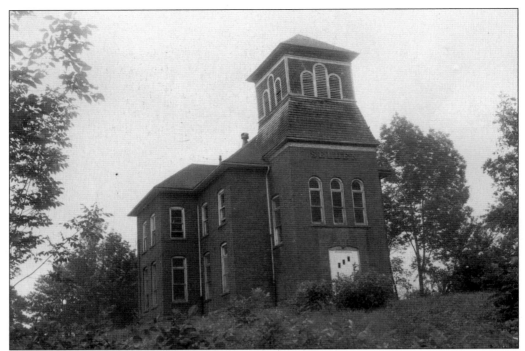

Seldon School was built and maintained with funds left by Olive Seldon. The brick building, with its distinctive tower, was used as a school until 1956. The town then gave it to the Berlin Youth Council for use as a youth center. Today, it is a private home. (Herald.)

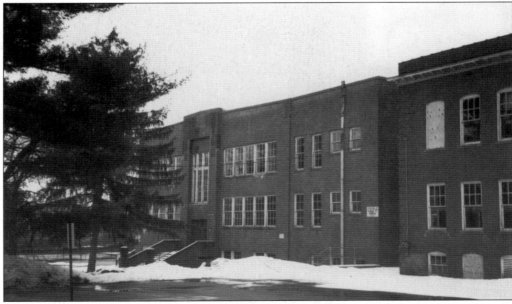

In 1931, the town made a commitment to have its own high school. In 1935, the Jean E. Hooker School opened, with classes for 9th, 10th, 11th, and 12th grades. In June 1936, the school's first class of 59 students graduated. The school had a staff of 17. One teacher with a master's degree was paid $1,400 per year. The yearbook was called *The Lamp*.

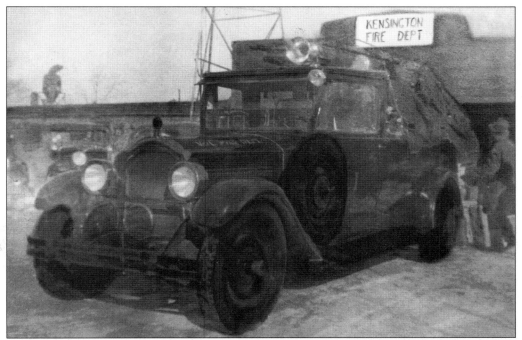

A 1927 Packard Hearse, donated by Peter Rosso and converted into a fire truck, was the first piece of equipment acquired by the Kensington Volunteer Fire Department. (Kensington Volunteer Fire Department.)

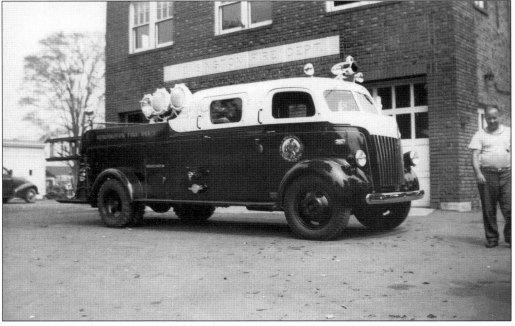

This Peter Pirsch Pumper, owned by the Kensington Volunteer Fire Department, was one of the earliest trucks built to hold all the firemen inside the cab of the truck. The apparatus took many prizes at firemen's conventions. (Kensington Volunteer Fire Department.)

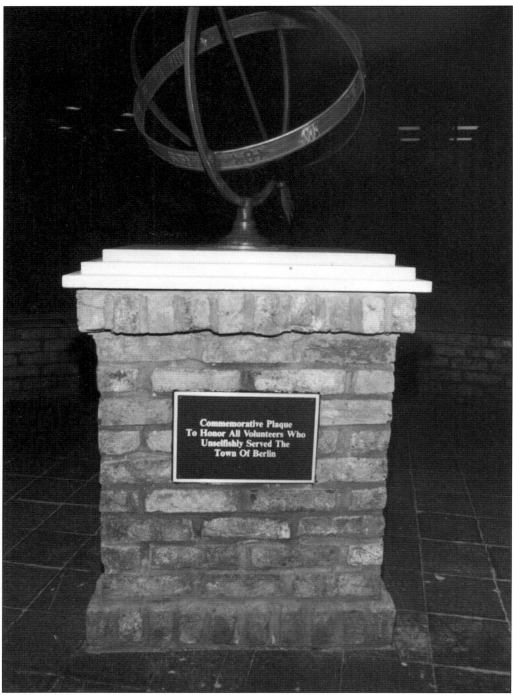

Berlin has always been about the people who live here and the way in which they live together as neighbors helping neighbors. From the very first settlers to the residents of today, the commemorative plaque says it all: "To Honor All Volunteers Who Unselfishly Served The Town Of Berlin." (Berlin-Peck Memorial Library.)

128